LITTLE BOOK OF

# BURBERRY

Published in 2023 by Welbeck
An imprint of Welbeck Non-Fiction Limited,
part of Welbeck Publishing Group.
Offices in: London – 20 Mortimer Street, London W1T 3JW & Sydney – 205 Commonwealth Street, Surry Hills 2010

www.welbeckpublishing.com

Design and layout © Welbeck Non-Fiction Limited 2023
Text © Darla-Jane Gilroy 2023

A CIP catalogue record for this book is available from the British Library.

ISBN 978-1-80279-267-6

Printed in China

10 9 8 7 6 5 4 3 2 1

LITTLE BOOK OF

# BURBERRY

The story of the iconic fashion house

DARLA-JANE GILROY

WELBECK

# CONTENTS

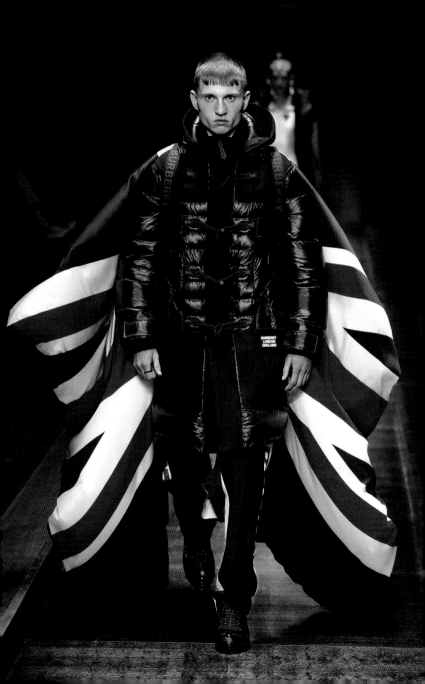

# INTRODUCTION

Founded in England over 160 years ago, and still based in London today, Burberry is one of the most sought-after brands in the world.

Its origins lie in a family-run business manufacturing functional clothing linked to innovation and adventure. The practical items of early days became the stepping stones into the fashion arena, where Burberry has become the epitome of British luxury. Burberry has defined elegance for decades and become woven into the very fabric of British society. The brand captures the essence of contemporary British culture by infusing heritage and tradition with modernity. Burberry has built a worldwide reputation for producing outerwear, a product category in which it excels through the exceptional quality of manufacture and the use of highly desirable, innovative fabrics combined with contemporary silhouettes.

Burberry offers a more comprehensive outerwear selection than many of its competitors. The most famous of the brand's outerwear styles is the iconic Burberry trench coat, which has remained the brand's signature piece for generations and makes up more than 30 per cent of its global sales.

OPPOSITE The 2019 A/W Burberry menswear collection featured a nylon bomber jacket with a dramatic Union Jack cape, embodying the theme of "England as a country of contrasts".

Although the trench coat is the pillar of the brand, this luxury fashion house prides itself on newness and relevance and maintains a position at the cutting edge of fashion, with a pioneering, forward-looking offer of ready-to-wear women's, men's and children's clothing. Burberry clothing ranges have evolved to include both relaxed informal pieces and structured contemporary tailoring, interspersed with the instantly recognizable Burberry trademark check pattern, which appears across all product categories and appeals to both traditional customers and the more avant-garde.

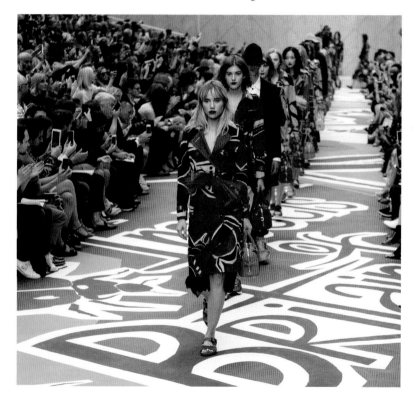

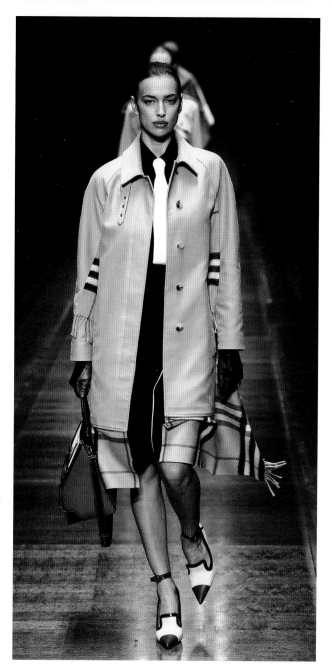

RIGHT Russian actress and model Irina Shayk in a contemporary, relaxed-fit, single-breasted trench coat, with draped scarf and matching accessories from the A/W 2019 collection.

Burberry has used luxury leather goods, footwear and accessories to attract new customers to the brand, with a series of signature styles and monogrammed pieces serving as a reminder of the brand's significance. The smaller leather goods, including wallets, phone cases and cardholders, all carry Burberry branding or feature the Burberry check, providing the perfect entry point into the brand and complimenting larger statement pieces.

BELOW A perfect accessory: a yellow quilted leather Lola bag with a signature TB logo plate and polished chain.

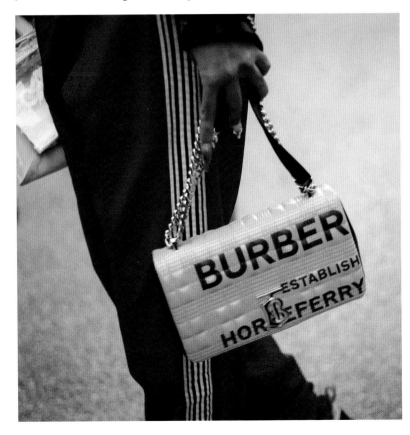

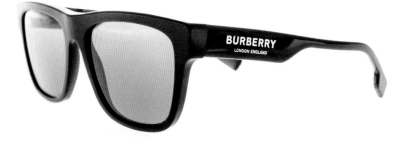

ABOVE Eyewear collections for men and women were introduced to complement the brand's ready-to-wear clothing and accessories collections. Designs feature subtle but easily recognizable elements of branding.

Since 2012, Burberry has spearheaded collections of eyewear, made up of classic aviator styles that reference the brand's heritage and connection with adventure, and more fashion-influenced rectangular styles that reflect the effortless, relaxed chic of the brand.

Burberry also has a presence in the beauty space through ranges of perfumes and cosmetics that evoke British cool. Cosmetics first appeared in 2013 and include everything for the lips, eyes and face. It rapidly became a favourite beauty brand through its exquisite quality, subtle colour palettes and premium packaging.

Burberry perfumes first launched in the 1980s, but the bestselling and perhaps best-known is Her, which debuted in 2018 and is now almost as iconic as the brand itself.

The launch of eyewear, cosmetics and perfumes created more accessibility for a luxury brand that had already gained a customer base through its clothing, and maintained customer

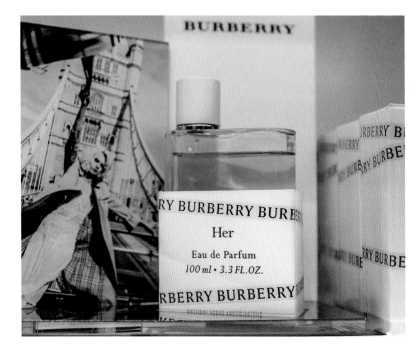

ABOVE Burberry Her Eau de Parfum, released in 2018, was the brand's pillar floral fragrance, designed to evoke the creative energy at the heart of London. A favourite with celebrities, it is Burberry's bestselling perfume to date.

loyalty with these smaller, but just as indulgent, purchases.

Not only is Burberry one of the most iconic British fashion brands in the world, but it is also among the most valuable. Burberry's financial success is such that the company was listed on the London Stock Exchange in 2002, featuring in the FTSE 100 Index. In 2015, Burberry ranked 73rd in Interbrand's Best Global Brands report, and in 2022, it was listed as the sixteenth most valuable luxury brand in the world by Brandirectory's Brand Finance valuation, with a total global revenue of £2.83 billion.

Through dynamic retail strategies and digital marketing initiatives, Burberry now has a total of 459 stores around the world and is anchored firmly in the luxury space.

Since 2019, Burberry has elevated its store network to align to the brand's luxury positioning and given the Burberry customer a gold-standard shopping experience. In fact, the brand continues to transform its direct-to-consumer channels to satisfy today's expectations.

Via its digital platforms, Burberry has built a powerful connection with a new generation of consumers and is now one of the most followed brands on social media. The first brand to use Snapchat, it has a presence across 20 different platforms, and a combined following of more than 50 million, inspiring

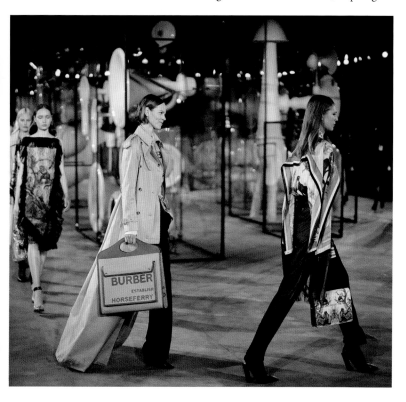

influencers to amplify the brand even further through their own social media channels.

Burberry continues to revitalize itself, and develop new product offerings, including athleisure pieces and trainers that appeal to young consumers while connecting with their concerns about climate emergency, sustainability and social justice. Burberry has made a longstanding commitment to working more sustainably.

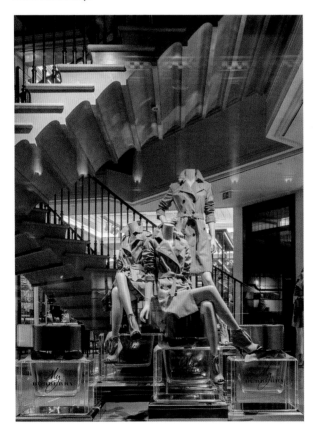

LEFT Burberry's powerful interior store designs, coupled with impactful displays, enhance the brand's luxury in-store experience. In 2014, Burberry displayed iconic trench coats against a cascading staircase in London to celebrate London Fashion Week.

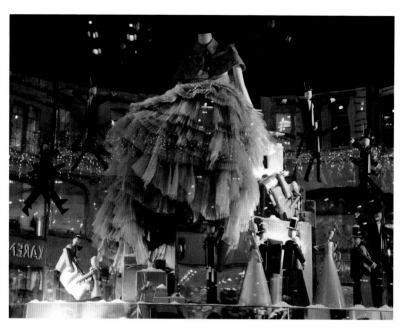

The brand has built a strong focus on social purpose, highlighted through the Burberry mission statement "Creativity Opens Spaces" and grounded in recognizing the need for actively addressing the challenges that face the fashion and luxury industries. Through a strategy focusing on addressing educational inequality, community cohesion and employability skills, Burberry employees can participate every year in volunteering and fundraising activities that contribute to the company's charitable initiatives.

The company has set ambitious targets to reduce its environmental footprint and donates a percentage of adjusted group profit before tax to charitable initiatives each year. Most of its philanthropic work is carried out through the Burberry foundation, set up in 2008 as an independent charity. The

ABOVE Burberry's elaborate shop interiors and window displays have been critical to the brand's success, typified by the Christmas 2014 display windows in the Knightsbridge store, London.

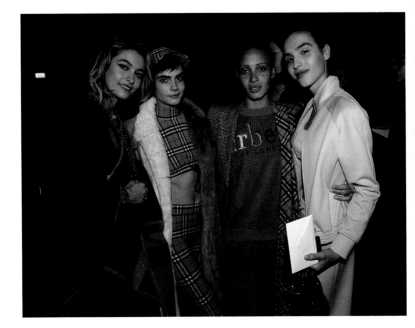

Foundation is dedicated to using the power of creativity to drive positive change globally and find innovative solutions to build a more sustainable future. It supports initiatives that mitigate the social, environmental and economic impacts of the luxury industry on communities worldwide.

Burberry's success and status as one of Britain's biggest luxury brands has seen it become a globally renowned brand worn by royalty, Hollywood A-listers and influencers alike. A purchase from Burberry is seen as a serious style investment. Unlike many heritage brands, Burberry has refused to stand still and remains creatively restless in a constant desire to originate cutting-edge style. Its iconic pieces of exceptional quality and durability are classic but also quirky, and forward-looking enough to attract and sustain new generations of customers.

ABOVE Cara Delevingne and Adwoa Aboah wearing pieces from the Burberry 2018 collection, Christopher Bailey's final collection for Burberry, pictured with Paris Jackson and Maxim Magnus at the Dimco Building in London.

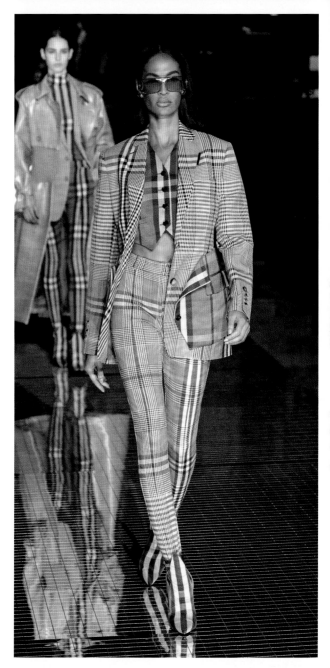

RIGHT Puerto Rican actress Joan Smalls, a favourite Burberry model, wore a playful mix-and-match check outfit on the catwalk in the A/W 2020 show. Elements of the brand's heritage outerwear pieces were reimagined into a contemporary sleek suit, with matching ankle boots.

**OUTERWEAR
INNOVATION**

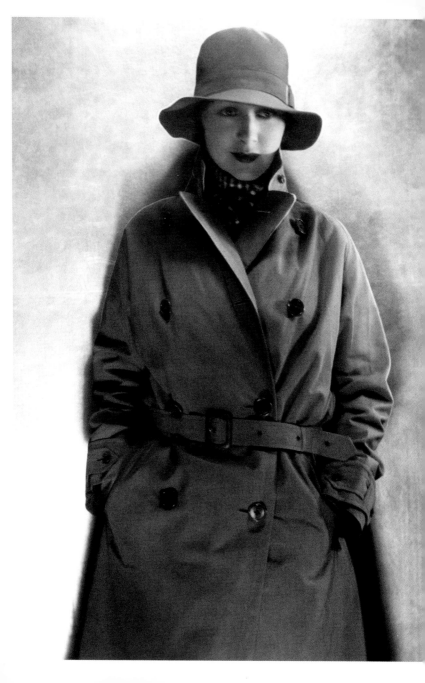

# ORIGINS OF
# AN ICON

Thomas Burberry was born on 27 August 1835 in Brockham Green, a village near Dorking in England.

Initially, he worked as a draper's apprentice, but in 1856, the 21-year-old Burberry opened his first business, a shop in Basingstoke, England. Burberry believed there was a demand for practical, everyday outdoor clothing to offer protection from the inclement British weather, and founded his business to respond to this demand. It quickly prospered, and by 1861 had employed 17 people. By 1870, the workforce had increased to 80 people, and Thomas Burberry had established himself as a leading developer, manufacturer and supplier of outdoor clothing.

Burberry had an eye for innovation. Always curious about current technology and new inventions, he began to experiment with materials to find a viable way to make waterproof clothing that could be used for hunting, fishing and other outdoor activities. As a result, Burberry invented gabardine in 1879. This would prove to be the first of many innovations that would fuel the company's success.

OPPOSITE The trench coat rapidly moved from functional to fashion garment. It became popular with women during the 1920s who wore it not only as a fashion item, but also as a statement of emancipation because of its masculine overtones.

Gabardine revolutionized outerwear garments because it was a new technique to waterproof fibres. Instead of coating the finished cloth in rubber, which produced heavy and uncomfortable garments, Burberry waterproofed the individual fibres by first coating them in lanolin, a fatty substance extracted from sheep's wool, and then weaving them into a tight twill pattern. Gabardine could be made from worsted wool (a fine, smooth yarn) or worsted wool and cotton blends to create a breathable, tearproof, waterproof and lightweight fabric. Burberry patented the method in 1888, paving the way for a new era in practicality and comfort across all outdoor clothing. The patent ensured that Burberry was its only stockist. He prospered, living comfortably with his wife and six children in a large, fully staffed house in Basingstoke set in 160 acres.

BELOW A postcard commemorates Burberry's pioneering Haymarket beaux arts store.

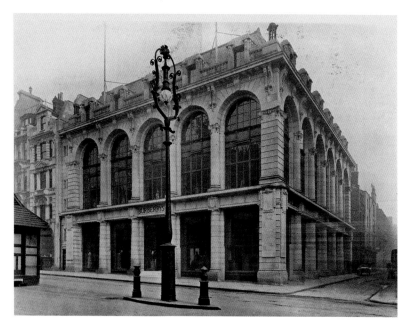

The company's success was such that, in 1891, Thomas Burberry opened a store in London's Haymarket, as well as stores in Manchester, Liverpool and Winchester. Through a network of agents, he began to export clothing abroad. He also expanded the range of clothing beyond outerwear, establishing the first links with fashionable – and less functional – clothing.

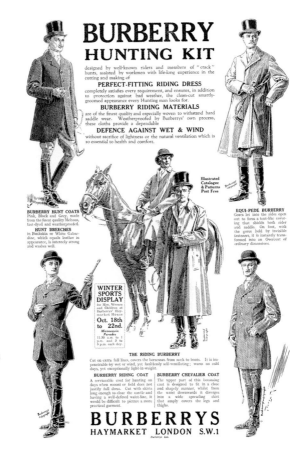

RIGHT Burberry's uncompromising commitment to producing high-quality, protective and functional sporting garments is evident in this early company advertisement for hunting kit and riding dress.

During the Boer War (1899–1902) Burberry's waterproof coats were informally adopted by British officers and in 1901, halfway through the conflict, Burberry became an official outfitter of the British Army. This began a long-lasting relationship with the British Army, cemented by a commission from the War Office to design a new service uniform for British officers.

The year 1901 also saw the launch of a public competition to design the company logo. The winning entry drew inspiration from thirteenth- and fourteenth-century armour housed in the Wallace Collection in London. It depicted a knight on horseback accompanied by the word prorsum, which means "forwards" in Latin. The Burberry Equestrian Knight logo was further refined and registered as a trademark in 1904.

RIGHT The brand's iconic Equestrian Knight figure is used to advertise its historic store in Boulevard Malesherbes, the first to be opened in Paris, France.

OPPOSITE Burberry acquired considerable recognition after outfitting Sir Ernest Shackleton with its groundbreaking gabardine fabric for his polar expeditions.

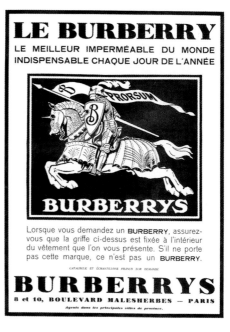

**LE BURBERRY**

LE MEILLEUR IMPERMÉABLE DU MONDE
INDISPENSABLE CHAQUE JOUR DE L'ANNÉE

PRORSUM

**BURBERRYS**

Lorsque vous demandez un **BURBERRY**, assurez-vous que la griffe ci-dessus est fixée à l'intérieur du vêtement que l'on vous présente. S'il ne porte pas cette marque, ce n'est pas un **BURBERRY**.

CATALOGUE ET ÉCHANTILLONS FRANCO SUR DEMANDE

**BURBERRYS**

8 et 10, BOULEVARD MALESHERBES — PARIS

Agents dans les principales villes de province.

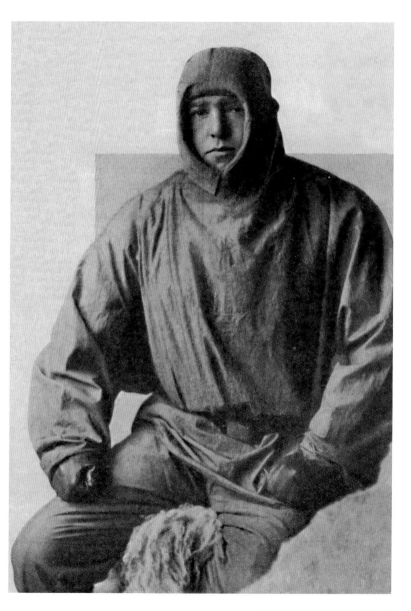

The triumph of gabardine lay in its functionality. It transformed cold-weather clothing, and became the choice of explorers and adventurers for decades. Burberry won acclaim from some of the greatest explorers of the late nineteenth and early twentieth centuries. In 1893, Fridtjof Nansen, the Norwegian zoologist and explorer, was the first explorer to wear Burberry gabardine during his expedition to the Arctic Circle.

In 1908, Air Commodore Edward Maitland wore Burberry gabardine to travel from England to Russia in a hot-air balloon, setting the British long-distance record. Aviator Claude Grahame-White wore gabardine to become the first person to make a night flight during the 1910 London to Manchester air race, completing the distance in less than 24 hours (then a considerable challenge). Burberry outfitted Norwegian explorer Captain Roald Amundsen when he became the first man to reach the South Pole in 1911, and also created a gabardine tent for him. Amundsen had been closely followed by British explorer Captain Robert Falcon Scott, who also reached the South Pole wearing Burberry clothing in 1912, but died on the return journey with his team of explorers, just a few miles from safety. British Explorer Sir Ernest Shackleton was determined to be the first explorer to cross the Antarctic continent from coast to coast, and wore gabardine for three expeditions, including the Imperial Trans-Antarctic Expedition of 1914–17, when his ship, *Endurance*, became stuck in ice.

The association of Burberry with exploration contributed to the company's success and by 1913, larger premises in London's Haymarket were needed. Architect Walter Cave was commissioned to design the three-storey, stone-fronted building in the beaux arts style, which remained the site of Burberry's headquarters until 2007.

OPPOSITE An advertisement for the Burberry tielocken raincoat from 1917.

# THE
# TIELOCKEN

*"The best protection against wind, snow and rain that I have ever met."—H.S.*

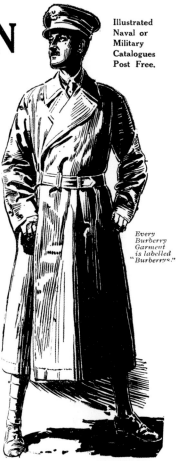

COMBINED with the smart and comfortable design of THE TIELOCKEN, is efficient weatherproofness — protection of the "dreadnought" order.

This quality is embodied in every thread of the coat. Put there by exclusive Burberry processes, and ingrained in every fibre of its material.

Burberry proofing needs no rubber or oiled-silk to make it effective. It excludes rain, sleet or snow, yet is entirely free from the unhealthy heat set up by air-tight fabrics.

Apart from wet-resistance, the material is so dense that no wind, however keen, can find entrance. This, in conjunction with warmth-giving linings of Wool or Fleece, makes THE TIELOCKEN the ideal safeguard for wintry weather.

Its design ensures that every vulnerable part of the body is doubly covered. From chin to knees, there's no chance for wet or cold to penetrate.

Another advantage of THE TIELOCKEN is its quick adjustment. A strap-and-buckle holds it securely—no buttons to fasten or lose.

*Every Burberry Garment is labelled "Burberrys."*

### Officers' Complete Kits in
### 2 to 4 Days or Ready for Use.

NAVAL & MILITARY WEATHERPROOFS
During the War BURBERRYS CLEAN AND REPROOF Officers' "Burberrys," Tielockens, Burfrons, and Burberry Trench-Warms FREE OF CHARGE

BURBERRYS' ANNUAL SALE.
During January many 1916 Civilian Topcoats and Suits, as well as Ladies' Coats and Gowns, are being sold at HALF USUAL PRICES or thereabouts. Full list of bargains on application.

# BURBERRYS HAYMARKET LONDON
### also 8 & 10 Boul. Malesherbes PARIS

28 OUTERWEAR INNOVATION

Thomas Burberry's second significant innovation came in 1912, when he patented the Tielocken, a style of military coat that would evolve into the trench coat as we know it today. The Tielocken combined a formal topcoat and a protective all-weather coat, creating a unique garment with a single strap, buckle fastening and a button at the collar.

The outbreak of the First World War in 1914 deepened the company's existing connections with the British Army. It was well positioned to provide clothing and equipment to the Armed Forces because of gabardine's tried-and-tested practical qualities. The Tielocken coat also proved a success. Designed for military use, it was a practical garment for men in the trenches — hence the name "trench coat".

New details were added, each serving a function and featuring on the Burberry Heritage trench coat to this day. The epaulettes were used both to display insignia denoting an officer's rank and to hold gloves. Metal D-rings that hung from its belt were used to attach essential field equipment. The "storm" flap provided protection from the rain, ensuring water ran down the shoulders rather than into the jacket.

In 1917, while the war continued, Thomas Burberry retired from the company. Two years later, in 1919, it received its first royal warrant, for tailoring, from King George V. (Two further royal warrants would be granted, by Queen Elizabeth II as a weatherproofer in 1955 and by King Charles III as an outfitter in 1989.)

By 1920, Burberry's outerwear empire had grown to have an impressive 1,750 wholesale agents around the world and the company became a limited public company, raising £2 million (£95 million today) in share capital. It remained in family ownership until 1955, when it was sold to Great Universal Stores.

OPPOSITE Burberry trench coats were featured in company advertisements during the First World War, where they were portrayed as the patriotic choice to protect army and naval officers.

BELOW Burberry as
a brand has always
been inspired by the
spirit of adventure.
In 1937, the De
Havilland DH.88
Comet known as
*The Burberry* took
off from Gravesend,
Kent, for the second
half of its record-
breaking flight to
Cape Town.

Thomas Burberry passed away in 1926, at the age of 90, and his
sons, Thomas Newman and Arthur, took over the business. His
legacy was such that the company continued to prosper. The
now iconic white, black, red and caramel Burberry check was
first designed in this decade, and used as a lining for outerwear
garments.

There remained a strong focus on customer service. To the
delight of customers, and to make shopping at Burberry's both
convenient and efficient, the company introduced same-day
delivery services using dedicated Burberry delivery vans within
London in 1934.

Throughout the 1930s, Burberry's long-standing relationship
with adventurers continued. The brand aligned itself with

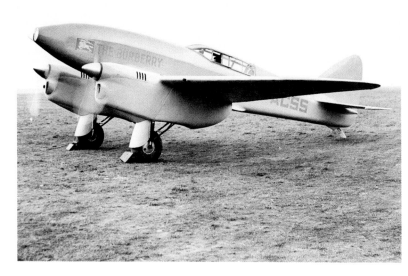

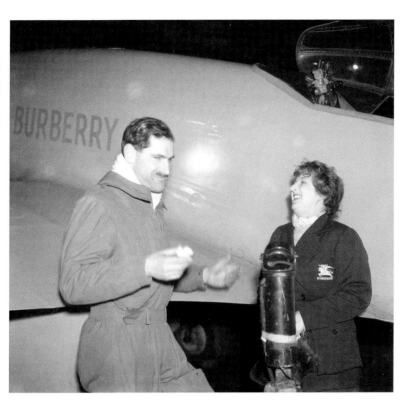

ABOVE Flying Officer
Arthur Clouston
and Betty Kirby-
Green piloted "The
Burberry", in which
they made their
historic flight dressed
in flying outfits made
of gabardine.

pioneering aviators, sponsoring a flight from London to South
Africa in a De Havilland DH.88 Comet aeroplane named *The
Burberry* in 1937. The record-breaking flight was piloted by
Arthur Clouston and Betty Kirby-Green, both wearing specially
designed Burberry gabardine clothing.

The outbreak of the Second World War in 1939 saw Burberry
once again supply the British Army with a range of military
clothing and accessories, including trench coats for both men
and women. The company also supplied clothing for the Royal
Air Force and the Royal Navy.

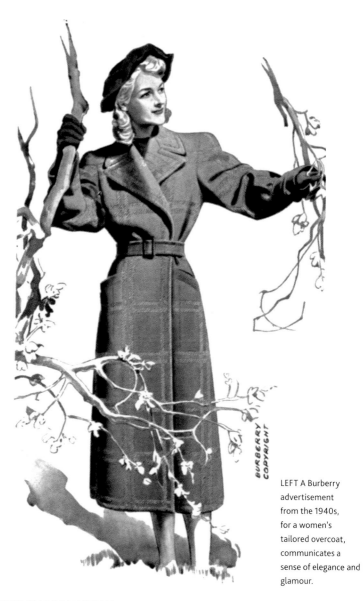

BURBERRY
COPYRIGHT

LEFT A Burberry
advertisement
from the 1940s,
for a women's
tailored overcoat,
communicates a
sense of elegance and
glamour.

BURBERRY
COPYRIGHT

LEFT Throughout the Second World War, Burberry continued to make civilian clothing despite the hardships of the war years, popularizing tailored suits for women, which retained the brand's signature function and style.

The austerity of wartime Britain did not prevent Burberry from making civilian clothing. Resourceful as ever, the company adapted its product range to include women's siren suits designed to be worn in an air raid.

At the height of war, the trench coat stepped into the spotlight and became part of popular culture when it featured in the film *Casablanca*. Made in Hollywood in 1942, the film starred screen

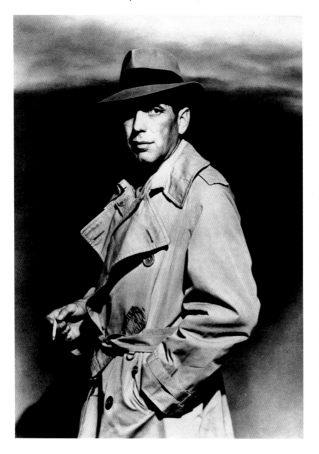

LEFT Humphrey Bogart wore a Burberry trench coat in one of the most iconic scenes in film history from *Casablanca*, released during the Second World War. At this time, the trench coat was perceived as a military garment. But the popularity of the film, coupled with Bogart's performance as a romantic lead, introduced the coat into everyday wear and elevated its status to culturally iconic clothing.

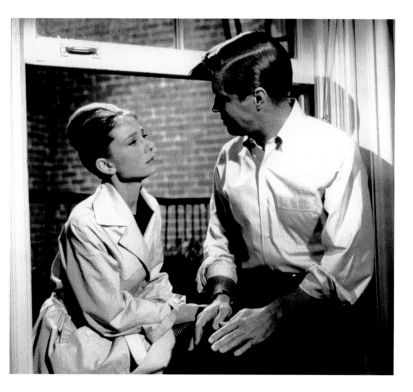

ABOVE Audrey
Hepburn and George
Peppard stared in the
1961 film *Breakfast at
Tiffany's*. Hepburn's
character Holly
Golightly creates
a series of style
moments throughout
the film, not least by
wearing a Burberry
trench coat.

legends Humphrey Bogart and Ingrid Bergman and was set in
wartime Casablanca. In its final sequence, Bogart wears a trench
coat made by Burberry. The success of the film popularized the
trench coat as a fashion item, and it would subsequently be
sported by a string of film stars and celebrities. Audrey Hepburn
wore a Burberry trench coat while playing Holly Golightly in
the 1961 film *Breakfast at Tiffany's*. Her iconic performance gave
the Burberry trench coat a new androgynous quality.

It was an indication of Burberry's national significance that
the company was asked to design the uniform for the British
women's Olympic team in 1964.

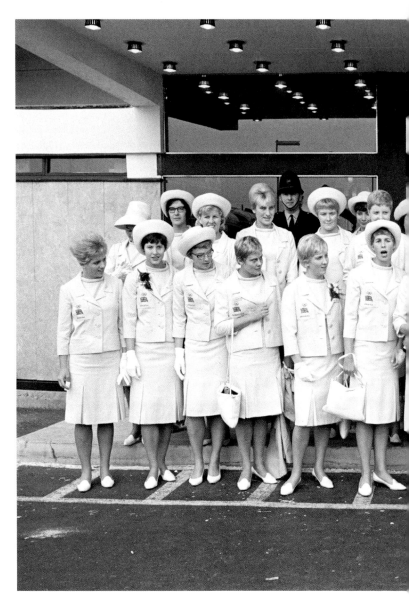

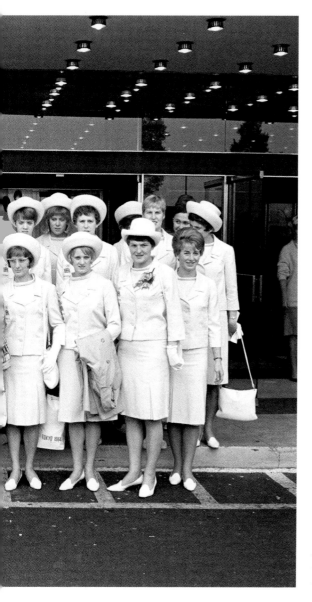

LEFT Burberry
designed a collection
for the women
athletes from the
British Olympic
team to attend the
1964 Tokyo Olympic
Games.

The following year, more than 100 years after the company's inception, one in five coats exported from Britain was a Burberry product. In 1972, to meet manufacturing demands, Burberry acquired a factory in Castleton, Yorkshire, to make trench coats. A workforce able to master intricate manufacturing processes, using over 100 individual steps that took up to a year to learn, showed the level of skill and craftsmanship that had built Burberry's global reputation for quality. Gabardine cloth woven

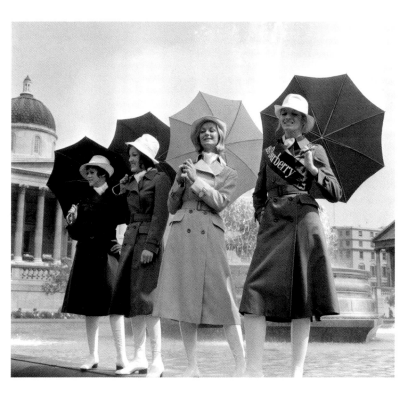

ABOVE Brenda Capwell won the title "Miss Burberry" in 1970. Here, she is photographed during a fashion shoot in Trafalgar Square with three other models.

at Burberry's textile mill in Cross Hills, originally opened in the 1880s, also near Keighley, supplied the factory, which had the capacity to produce 5,000 trench coats a week.

The 1970s and 1980s precipitated enormous retail growth in America, where Burberry opened a New York flagship store at East 57th Street, and stores in San Francisco, Chicago, Boston, Philadelphia, Washington, Troy, Michigan, Manhasset (New York), Short Hills (New Jersey) and California. During this period, the company began to diversify its product range, manufacturing under license but controlled by the company head office in London. Products were sold through independent

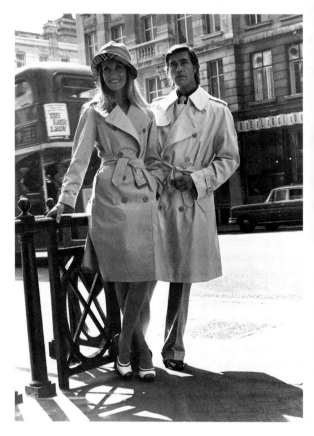

RIGHT An expression of style, craft and design: models pose wearing trench coats against a backdrop of a London bus – the Trench 40 (his) and the Glenco (her) – from the S/S 1974 collection.

OPPOSITE Actress Meryl Streep starred in the 1979 film *Kramer vs. Kramer* wearing a Burberry trench coat, a status symbol for young professionals at the time.

retail stores as well as the Burberry stores worldwide, growing profits significantly.

In 1987, the company even moved into food production, selling preserves, mustards, teas and biscuits – but by the mid 1990s, the brand had lost direction, marking a sharp decline in profits. This culminated with a significant drop in profits in 1997 from £62 million to £25 million. It was time for owners Great Universal Stores (GUS) to take action to revitalize the company.

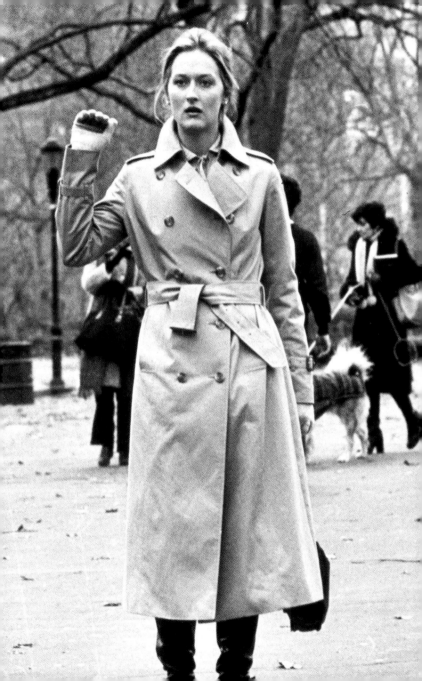

# NEW
# DIRECTIONS

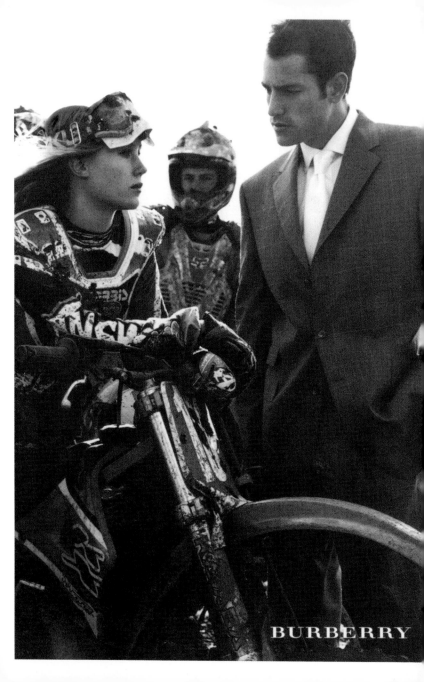

BURBERRY

# BUILDING A LUXURY BRAND

Throughout Burberry's history, the company had known constant success and continued growth.

In the 1990s, and for the first time, Burberry faced slow sales, a drop in profits and a need to rationalize its positioning in the marketplace.

In 1997, Rose Marie Bravo, an icon of the fashion industry, was hired as Burberry's chief executive officer. Under her guidance and extensive experience, the brand rediscovered its standards of excellence to establish itself as a globally recognized luxury brand for the twenty-first century.

Rose Marie Bravo grew up in the Bronx, New York. Her parents were originally from Italy, her father a barber and her mother a seamstress. Her ambition saw her graduate with an English degree from Fordham University, and she then became an assistant buyer for Abraham & Straus, a New York department store group. This gave Rose her first taste of the fashion industry, and it was not long before she joined Manhattan retailer Macy's. There, she was promoted

OPPOSITE The monochrome Burberry ads of the late 1990s marked a significant moment in the communication of the brand's aesthetic by referencing its past but speaking to its future.

to group vice president and then to senior vice president of merchandising, and when Macy's acquired I. Magnin, a West Coast premium retail business, Bravo was the obvious choice to restructure the business. This was the start of her journey into luxury fashion, which would see Bravo become the first woman president of the legendary Saks Fifth Avenue – where she cherry-picked the best ascending luxury brands, such as Gucci and Prada, for the store group, which she ultimately left for Burberry.

Once appointed as CEO of Burberry, Bravo immediately set about a radical restructuring. She recognized that the brand was out of touch with consumer trends and needed a youthful, more dynamic image and creative direction. She established a new management team and began to revitalize the brand with an expanded product range to boost profits. The company rebranded from "Burberry's" to "Burberry" and art director Fabien Baron was commissioned to update the Equestrian Knight logo. As part of an imaginative communications strategy, Bravo signed supermodel Kate Moss to be the fresh new face of Burberry. Moss typified Britishness through the lens of free-spirited irreverence and spoke to a new generation of customers.

Burberry staged the first catwalk show for its inaugural collection in 1999 during London Fashion Week. The Spring/Summer 2000 womenswear collection revealed feminine, light-hearted clothing: a playful interpretation of the Burberry check was integrated into long, flowing, iridescent silk skirts, and there were trench coats made of sailcloth and double-breasted biker jackets made from suede. The collection bore the Burberry hallmark, but reflected the Cool Britannia culture of the time. As a result, Burberry was awarded British Classic Design Collection of the Year two years running.

OPPOSITE
Supermodel Kate Moss would become a signature model for Burberry. Such was her standing that the "Kate Moss effect" helped to restore Burberry's reputation and boost sales. The S/S 2007 collection marked the creative coming of age for Christopher Bailey.

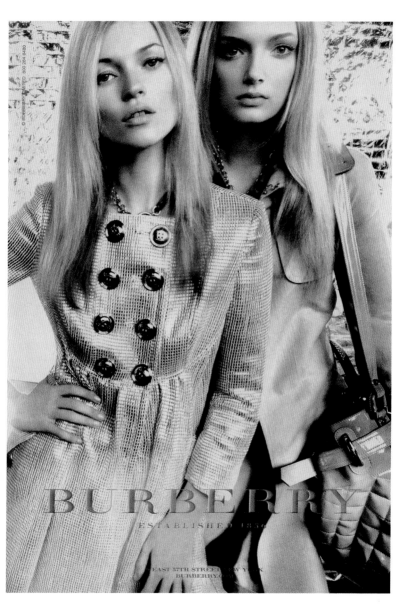

BURBERRY

ESTABLISHED 1856

EAST 57TH STREET NEW YORK
BURBERRY.COM

The collections were well received, and profits rose, but the transformation into a modern luxury brand was not yet complete. What was needed was an energetic, new creative voice to speak for Burberry. Bravo turned to a young designer, Christopher Bailey.

Bailey was born in Yorkshire, England in 1971, the son of a carpenter and a window dresser. He grew up in a relaxed rural setting but was always fascinated by his father's craftsmanship and ability to construct intricate objects. An interest in art led Bailey to London, where he graduated from the world-renowned Royal College of Art in 1994 with a master's degree in fashion. Later, he said: "It was during my time at the RCA that I learned the importance of expressing yourself, and having confidence and belief in your vision."

After graduation, he was immediately snapped up as womenswear designer for Donna Karan in New York, then moved to Gucci as senior womenswear designer in 1996. In 2001, Christopher Bailey joined Burberry as design director, with full responsibility for the company's overall image. This included everything from advertising, corporate art direction, store design and visuals to the design of all Burberry collections and product lines. His appointment marked the beginning of a new creative era for the company. Over the course of the next 17 years, Christopher Bailey became the most successful and celebrated designer of his generation.

Burberry had always been closely associated with the traditional outdoor pursuits of the affluent British upper classes through its outerwear, but it had become synonymous with the outmoded "Sloane Ranger" culture of the early 1980s, typified by Princess Diana. Recognizing that the age of aristocracy had truly passed, Bailey, a four-time winner of Designer of the Year at the prestigious British Fashion Awards, transformed the

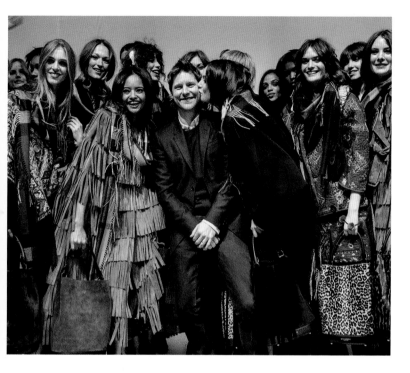

ABOVE Christopher Bailey with models backstage at the Burberry Prorsum show in 2015.

fortunes of the company by shifting its aesthetic and image from classic outerwear to contemporary fashion. In the process, he gave Burberry relevance in an era when heavy branding from the "right" luxury fashion houses conveyed status, and was embraced by a newly emerging celebrity class.

Burberry clothing began to appear in the wardrobes of rock stars, actors, sportsmen and influencers alike. Many were even featured in Burberry ad campaigns, such as Romeo Beckham, the then 11-year-old son of celebrity couple David and Victoria Beckham, and actors Matt Smith and Sienna Miller, alongside high-profile British models Stella Tennant, Naomi Campbell, Cara Delevingne and Adwoa Aboah.

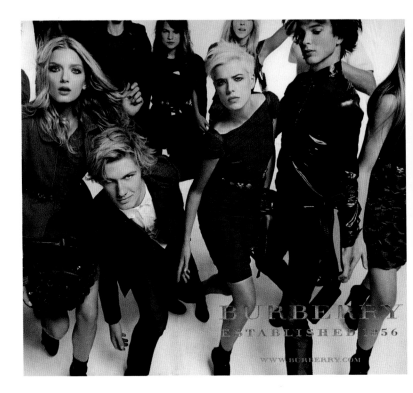

BURBERRY
ESTABLISHED 1856
WWW.BURBERRY.COM

ABOVE Christopher Bailey's creative vision transformed Burberry from 2001. Models such as Stella Tennant, Agyness Deyn, Sasha Pivovarova and Freja Beha Erichsen became synonymous with the brand's forward-looking direction.

Bailey's efforts were rewarded when Burberry won the British Fashion Council award for Best Contemporary Collection in 2001, and the following year, in 2002, Burberry was floated on the London Stock Exchange.

The success of Bailey as a creative force elevated Burberry to become the most successful British fashion brand ever and created a halo effect for the whole of the British fashion industry.

Throughout his 17 years at Burberry, in a role that began as design director and evolved to include CEO and finally president, Christopher Bailey anticipated social changes that would inform new fashion trends, his instincts placing Burberry

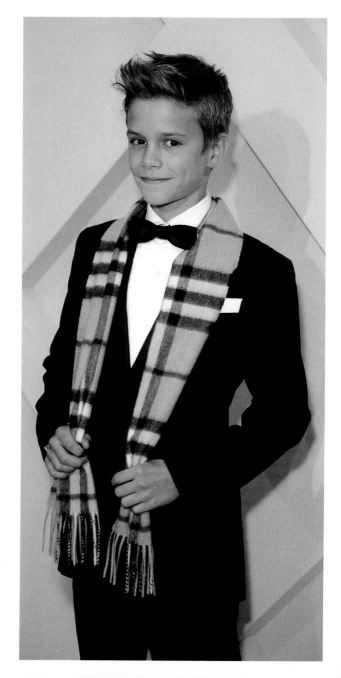

RIGHT Romeo
Beckham, star of
the Burberry 2014
Christmas campaign,
attends the launch
of the brand's festive
campaign.

at the forefront of innovations in design, manufacturing, retail and corporate responsibility.

One of the first in the fashion industry to embed ethical and sustainable practice into the culture of a fashion brand, Bailey established the Burberry Foundation in 2008, a charity committed to supporting young people. Burberry would go on to become the first luxury brand to join the Ethical Trading Initiative in 2011. He also initiated a partnership with the Royal College of Art in 2017 to create the Burberry Material Futures Research Group, which innovates sustainable materials and manufacturing processes. The following year, Burberry would join the Ellen MacArthur Foundation initiative "Make Fashion Circular", set up to address the environmental impact of the fashion industry.

To celebrate the 25th anniversary of London Fashion Week, Bailey showed his Spring/Summer 2010 womenswear collection in London rather than Milan, emphasizing the importance of British fashion. The collection closed London Fashion Week with an unforgettable array of glamorous minidresses, draped details and sequin-encrusted trench coats. With just the right amount of nostalgia, Bailey kept the iconic trench alive and relevant to a youthful audience, offering silvered gabardine fabric, slashed suede and innovative knotted techniques.

In the front row were celebrities such as Emma Watson, Gwyneth Paltrow, Mary-Kate Olsen, Victoria Beckham, Daisy Lowe, Freida Pinto and Dev Patel, all wearing pieces from the catwalk. The show was live-streamed to private audiences in London, Paris, Los Angeles, Tokyo and Dubai, making Burberry the first brand ever to do so.

Within a year, Burberry would debut collections on Twitter before they were shown on the catwalk.

RIGHT A model wears a powder-blue trench coat over a blue lamé skirt in the S/S 2005 catwalk show, an original collection that skilfully combined clothes, accessories and a strong brand identity.

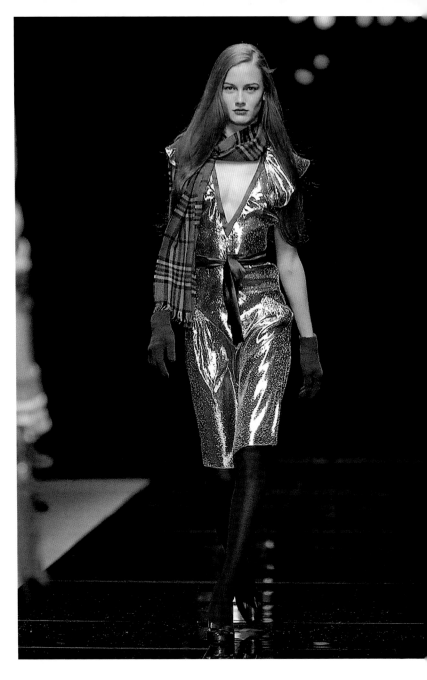

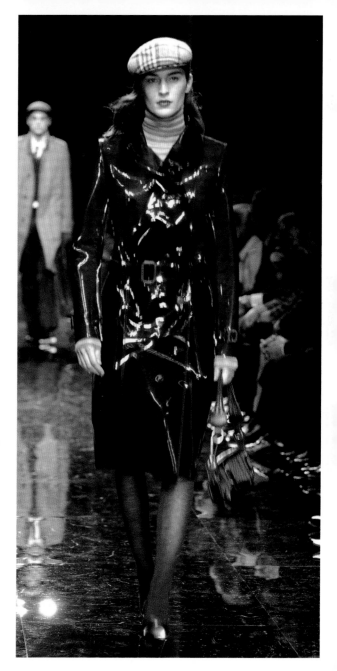

RIGHT A timeless design, the trench coat appears in many iterations. This, in petrol-blue patent leather, featured in the Burberry A/W 2004 collection.

OPPOSITE The Burberry A/W 2004 show was a quirky homage to the fluid silhouettes of the 1930s.

The year 2016 marked the 160th anniversary of the creation of Burberry. Christopher Bailey wanted to celebrate the heritage, innovation and vision of the brand's founder Thomas Burberry through a short film by award-winning director Asif Kapadia. *The Tale of Thomas Burberry*, a three-minute commemorative film, reimagined events that had shaped the brand and starred many of Burberry's celebrity clients, including Sienna Miller, Lily James and Dominic West, with Domhnall Gleeson as Thomas Burberry.

In September 2016, Bailey also took the bold move to consolidate men's and womenswear into one seasonless event and pioneered the "see now, buy now" model, making items from the catwalk available to buy the following day, both in stores and online.

In November 2017, Bailey announced his departure from Burberry. His February 2018 show would be his last. The length of his tenure, and the extent of his transformation of the brand, made it hard to separate Bailey from Burberry. The announcement caused a fever of speculation as to who his successor would be and Burberry shares to fall 2 per cent.

Thanks to Bailey, Burberry had captured much of the values of modern Britain and his final show did not disappoint. The show featured rainbow motifs signifying the brand's support of LGBTQ+ communities, and included celebrity models long synonymous with Burberry, such as Adwoa Aboah dressed in rainbow stripes and Cara Delevingne in a fake-fur rainbow coat. A rainbow version of the Burberry check symbolized Bailey's personal commitment to tolerance and diversity and his confidence in reimagining a signature feature of the brand.

Said Bailey: "My final collection here at Burberry is dedicated to and in support of some of the best and brightest organizations supporting LGBTQ+ youth around the world.

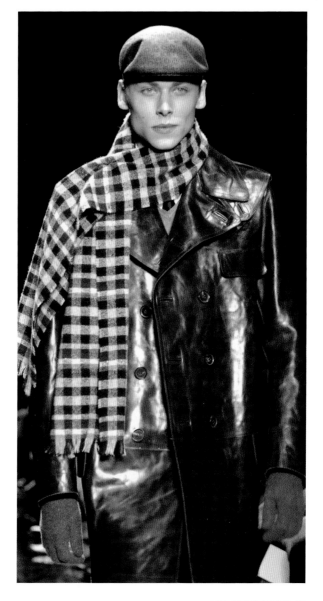

RIGHT A model wearing a leather trench coat and check scarf on the catwalk during the Burberry A/W 2004 fashion show in Tokyo.

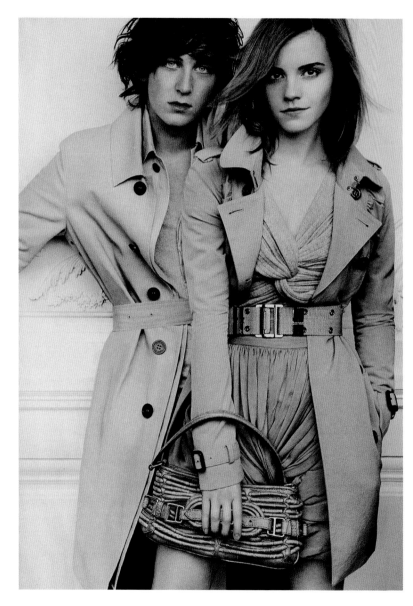

There has never been a more important time to say that in our diversity lies our strength, and our creativity."

Italian designer Riccardo Tisci was announced as Bailey's successor in March 2018. Tisci's expertise in interpreting athleisurewear and casual clothing for the luxury sector, coupled with his reputation for dark romanticism established during 12 years as creative director at Givenchy, made him a substantial presence within the global fashion industry.

Riccardo Tisci was born in Cermenate, near Lake Como, in 1974. His parents were from the south of Italy, but he grew up in Milan with his eight older sisters, and lost his father when he was just six.

He studied in Italy at the Istituto d'Arte Applicata e Design in Cantù, and then moved to London to attend Central Saint Martins College of Art and Design, graduating in 1999. After graduation, Tisci worked for sportswear brand Puma and designer Antonio Berardi while also producing his own collections.

In 2005, Tisci became creative director for Givenchy women's haute couture and ready-to-wear lines, adding his stamp to the elegant, aristocratic house. In 2008, he took over menswear and accessories before stepping away from the brand in 2017.

The question on the lips of many fashionistas was this: how would Tisci interpret the Burberry history and heritage to retain the brand's Britishness?

In response, Tisci said: "I'm not British, obviously, but I lived here when I was young. I studied here. I graduated here. I have to give all my gratitude to England. England made me. But at the same time, what is it today, to be British?" Tisci came to Burberry with cool embedded in his DNA. He had designed the wedding outfits for Kanye West and Kim

OPPOSITE Emma Watson and George Craig photographed for the S/S 2010 Burberry advertising campaign, reflecting a younger and edgier image of the brand.

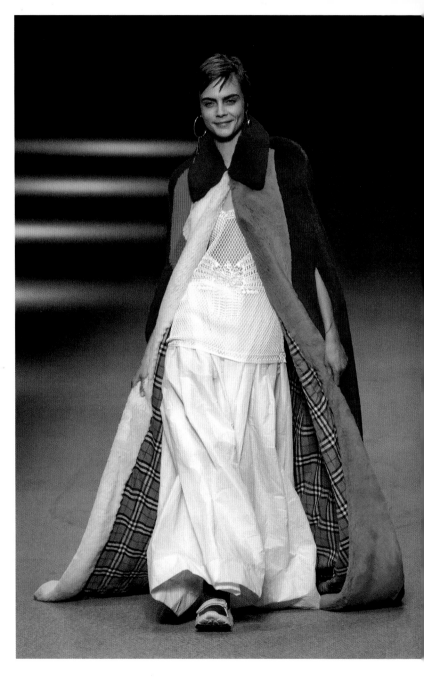

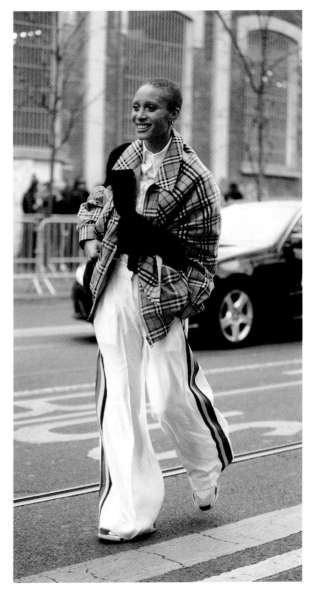

RIGHT Adwoa Aboah champions Burberry check during Milan Fashion Week in 2018.

OPPOSITE Cara Delevingne on the catwalk wearing a faux-fur rainbow cape during the Burberry A/W 2018 show.

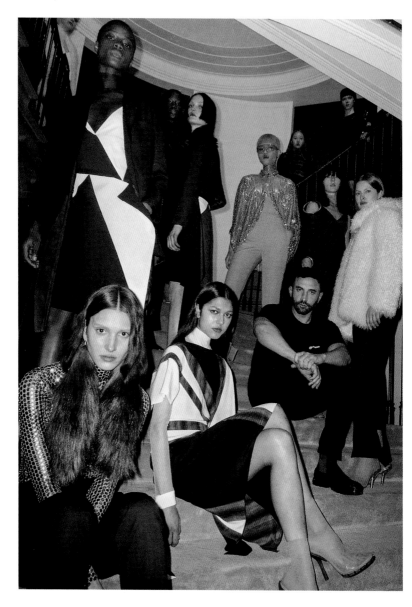

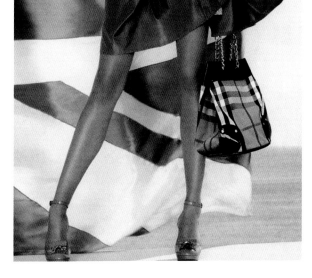

BURBERRY
9 EAST 57TH STREET NEW YORK

RIGHT Indelibly linked to Britishness and as unmistakable as the Union Jack itself, Burberry's S/S 2006 advertising campaign.

OPPOSITE Riccardo Tisci backstage with models during the Burberry A/W 2021 womenswear presentation.

Kardashian in 2014, collaborated with Nike in 2016, and he counted music legend Madonna and artist Marina Abramović as friends. He collaborated with British rapper M.I.A. within a year of arriving at Burberry and dressed singers Ariana Grande and Rihanna and model Gigi Hadid. If anyone could define Britishness for Gen Z in a post-Brexit landscape, it would be Tisci.

Tisci specifically appealed to the hypebeast demographic, adopting the "drop culture" of brands such as Supreme to create limited-edition pieces each month, along with more affordable pieces in his B series. In 2018, he collaborated with Russian streetwear designer Gosha Rubchinskiy to revisit the Burberry check, despite its overexposure and associations with the casual culture of the 1990s.

He enlisted the art director and graphic designer Peter Saville to reinvent the brand's logo as an impactful monogram, which featured in Tisci's debut collection of traditional tailoring layered under anoraks and bomber jackets in a reserved colour palette of navy, black, grey and khaki blended with distinctly printed streetwear pieces. He explored the contrasts in British culture and weather in his Autumn/Winter 2019 collection Tempest, and again used his eye for graphics to blend tailored and streetwear pieces.

Tisci mirrored the collaborative mindset of a new Burberry audience. He used this to bring his collections to life by creating a collaborative precollection space for a different creative voice each season. The first collaboration in the New Creative series, entitled "Friends and Family", was with Brazilian transgender model Lea T, reflecting questions of identity and the outdoors – recurrent themes in the story of Burberry.

In autumn 2022, Tisci stepped down from Burberry and Daniel Lee, formerly of Bottega Veneta, moved into the role.

OPPOSITE Known for her collaborations with Burberry, Maya Arulpragasam aka M.I.A. attends the UK Premiere of the documentary film *Matangi/Maya/M.I.A.* in London, wearing a printed overcoat and matching shorts from the S/S 2019 collection.

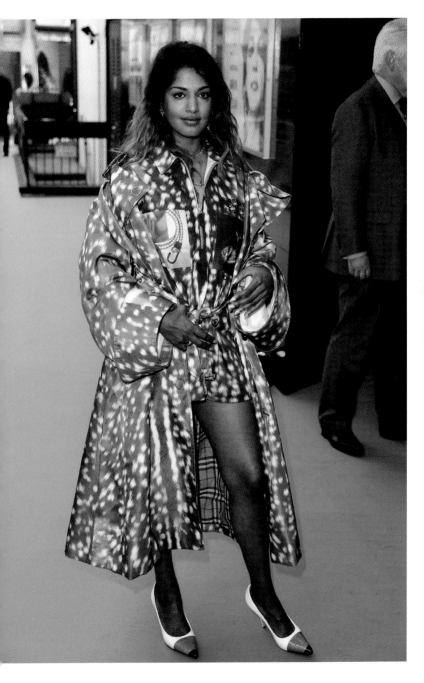

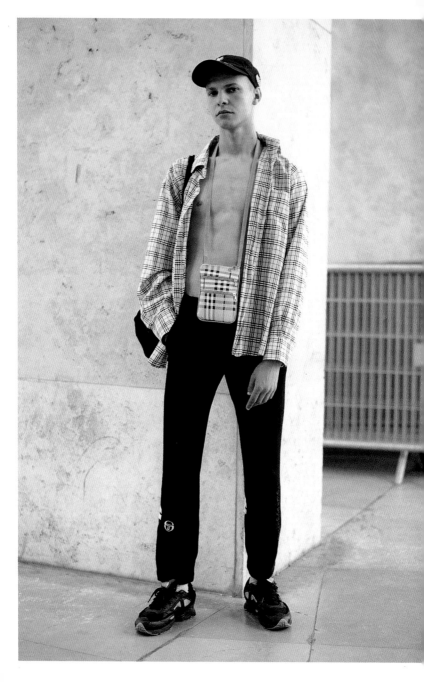

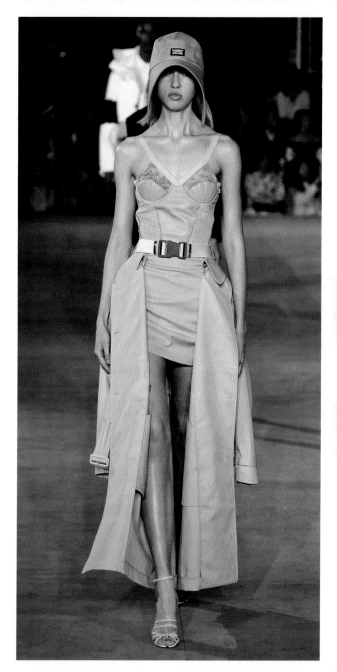

RIGHT The S/S 2020 fashion show drew inspiration from the brand's prominent past, highlighting a crisp, muted colour palette and garments that played with length and volume.

OPPOSITE Street style meets catwalk chic – a fashionista poses wearing a Burberry check outfit during Paris Fashion Week.

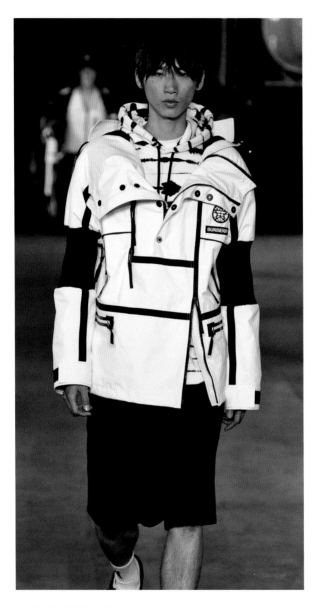

LEFT A model wears a bold, black and white, streetwear-inspired parka at the Burberry menswear S/S 2020 fashion show during London Fashion Week.

OPPOSITE Burberry muse Agyness Deyn returns to the catwalk after a 12-year absence to model a stunning diamanté-encrusted coat from the S/S 2020 collection.

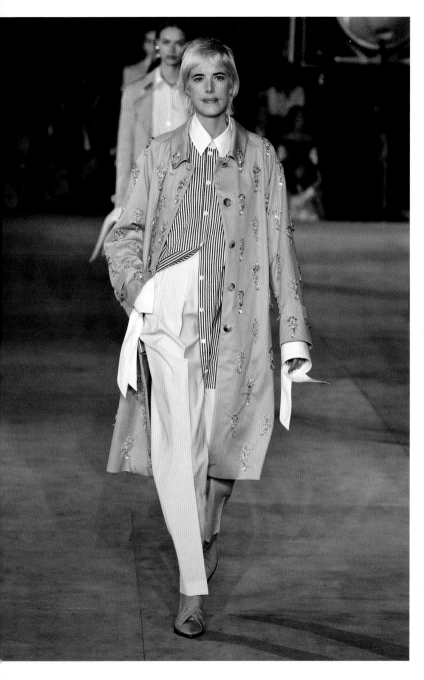

ICONIC
CHECK

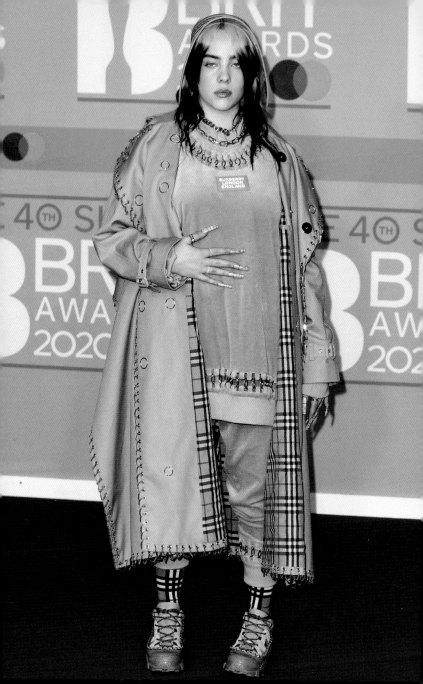

# A MARK OF LUXURY

The Burberry check is a tartan design woven in patterns of intersecting lines in black, red, white and camel.

It is officially known as the "Haymarket Check", after the street where the first Burberry shop opened in London. The check comes in several different colourways, such as Supernova, Exploded and The Beat. Now protected by a trademark, it was originally created in the 1920s and was first used to line Burberry trench coats as a practical and attractive feature for the comfortable weatherproof outerwear.

Today, it is as instantly recognizable as the flag of the United Kingdom, the Union Jack. Throughout its history, it has represented both ends of the spectrum of class in British society. The Burberry check has appeared at hunting parties and also on football terraces and, in its most recent iteration, Rainbow, has become a symbol of tolerance and inclusion. More than any other signature design, the Burberry check tells a compelling story of cultural shifts in British society to reveal a picture of how different consumer tribes interpret luxury.

OPPOSITE Billie Eilish proves there is a Burberry trench coat for everyone, with her choice of a voluminous style with eyelets and trademark check lining accessorized with matching nails to attend the BRIT Awards in 2020.

The first sense that the Burberry check would step outside the practical function of a lining came in 1967. Jacqueline Dillemman, a buyer for Burberry's store in Paris, was preparing to welcome the British Ambassador, Sir Patrick Reilly, and decided to add a display of trench coats to build further interest. Dillemman reversed one of the coats, showing the check lining – which proved an instant success with customers. The store was inundated with requests for items featuring the check pattern. The store made several hundred umbrellas that immediately sold out and then decided to make cashmere check scarves that proved just as popular. Unwittingly, Burberry had created a status symbol of luxury and wealth, which would ultimately prove accessible to a wider demographic than the company's exclusive current customers.

In the 1970s, the Burberry check was adopted by British royals like the young Princess Anne and Prince Charles and the photographer Lord Patrick Lichfield, who not only featured in but also shot several Burberry advertising campaigns. By 1976, the check had become so popular that it was used on scarves, shirts, luggage and handbags. In the 1980s, it was quickly taken up by a new generation of the upper classes, led by Lady Diana Spencer, soon to become the Princess of Wales. She promoted a style-signifying class and status through pearl necklaces, preppy white blouses, cardigans and Burberry items, a look epitomized in *The Official Sloane Ranger Handbook* (1982). Upon her death in 1997, Burberry created a version of the check to commemorate her, called the Diana Memorial Check, in navy, black and red.

In 1999, and for the first time, the check made its way from a lining onto the outside of Burberry trench coats, creating even more interest in the Burberry check as a code to convey wealth and status. However, its success did not come without a

OPPOSITE A model displaying the iconic lining of her Burberry trench.

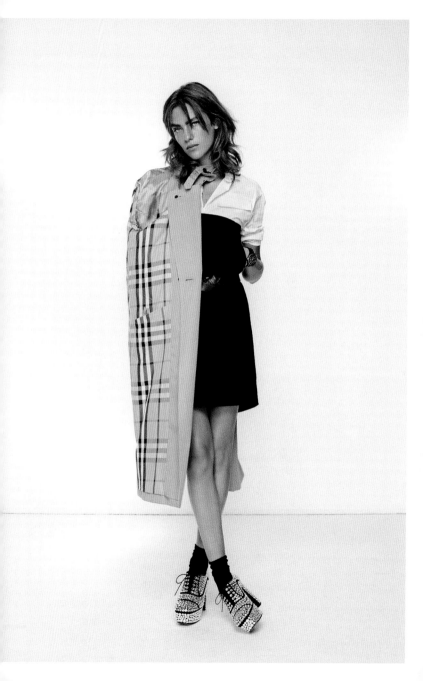

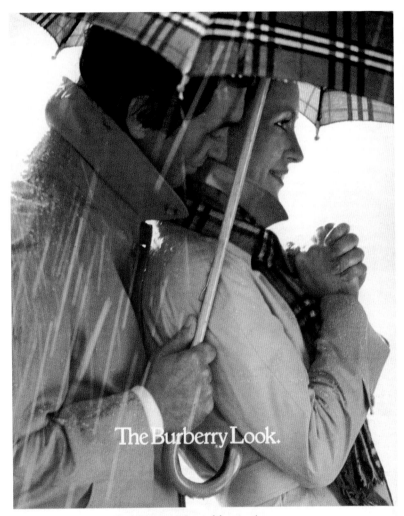

The Burberry Look.

Classic Burberry weatherproofs for men and women
available from leading shops and stores throughout the country.

Burberrys
OF LONDON

For stockists list, contact Burberrys International Limited, Suite 1714, 1290 Avenue of the Americas, New York, NY 10019. Tel: (212) 246 2570.
'Burberry' and 'Burberrys' are the registered trade marks of Burberrys Limited, London.

price. During the 1980s and 1990s, the Burberry check was one of the most copied designs in the world, and the market began to be filled with counterfeit Burberry merchandise. Overexposure was compounded by the fact that Burberry had instigated a large-scale licensing campaign in a bid to raise sales, which saw the check design applied indiscriminately to everything and anything.

This significantly weakened Burberry's appeal to high-end consumers, the brand's target demographic. Its branded items were now more accessible to lower-income consumers hungry for brands synonymous with status and success, no matter whether those products were authentic or counterfeit. This rise in the popularity of recognized brands, such as Gucci, Chanel and, of course, Burberry, was part of what has become known in Britain as "chav" culture. Chavs were young people from low socioeconomic backgrounds, known for dressing in heavily branded clothing, and they started a phenomenon that gained media attention in the late 1990s and early 2000s. The chav design of choice was the Burberry check, worn by football supporters known as the "Burberry Boys", who became notorious for running riot.

Excessive use of the check had initially been embraced by the brand: in the campaign for Spring 2000, Kate Moss was a Burberry bride and the entire wedding party wore Burberry check. The design was truly ubiquitous. "Chav", though, was a term that became largely pejorative – and the pervasiveness of the Burberry design became increasingly problematic for the brand. In 2002, a tabloid photograph of British soap star Danniella Westbrook caught her dressed from head to toe in Burberry check, and carrying branded accessories: handbag, umbrella and a baby stroller. Her baby was wearing the check too.

OPPOSITE The Burberry check umbrella quickly became an icon in its armoury and a powerful signifier of the brand's prestige.

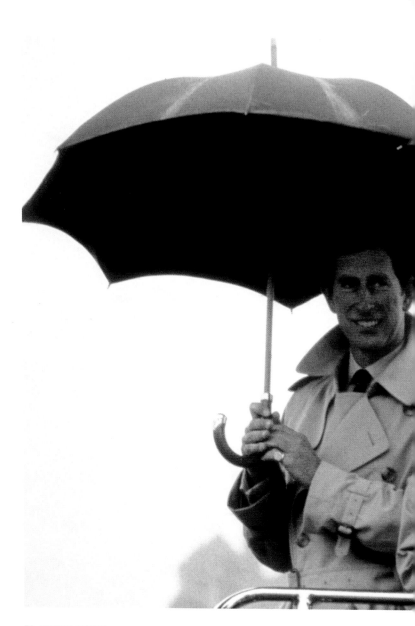

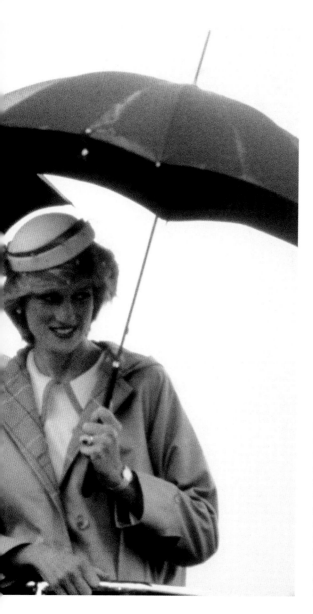

LEFT The then-Prince and Princess of Wales, Charles and Diana, provided powerful testimonials for the Burberry brand among the British upper classes. Here, they brave the elements in Burberry trench coats while on holiday in Nova Scotia in 1983.

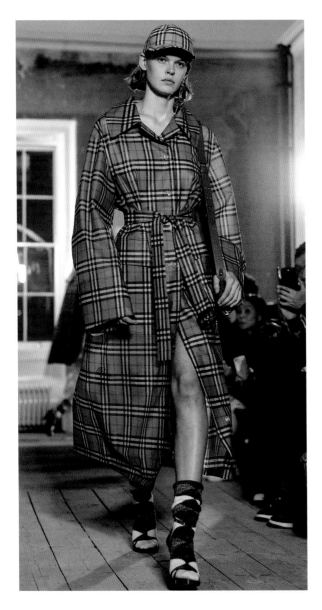

LEFT A celebration
on the catwalk of
Burberry's early
2000s maximalist
approach to its
most compelling
signature, the
Haymarket check.

This became the defining image of "chav check", and Burberry
customers in Britain deserted the brand. High-end retailers
in the UK, including Harvey Nichols and Selfridges, stopped
stocking it altogether. Harrods continued, but stocked only the
most conservative items from the collections, and the iconic
check began to disappear.

The company now embarked on a strategy to reduce those
items that were undermining the Burberry name, buying back
numerous licenses and becoming more protective of the brand
identity. By 2011, less than 10 per cent of Burberry products
featured prominent use of the check. The check design was
brought back in-house and only gradually reintroduced as
a more exclusive design offer, once again fuelling significant

growth. Working with celebrities such as Kate Moss, Naomi Campbell, Eddie Redmayne and James Corden, who all featured in advertising campaigns, Burberry's reputation was gradually restored.

Few brands could have recovered from such a damaging period, but Burberry found a happy medium between the Sloane Rangers and the Burberry Boys to reimagine the check. Its history has been rewritten through collaborations in 2018 with Vivienne Westwood, the fashion designer, activist and provocateur, and Gosha Rubchinskiy, the Russian streetwear designer, which has renewed confidence in Burberry's signature design.

The collaboration with Gosha Rubchinskiy even paid homage to chav culture, blending streetwear and football culture in perfectly tailored check shirts and matching shorts, Harrington jackets, colourblocked trench coats lined in check and the tracksuits, bucket hats and baseball caps that were obligatory in the 1990s. The collaboration introduced the check to a new generation with a subtle, tongue-in-cheek approach to social hierarchy and class, fusing British and Russian working-class cultures.

Vivienne Westwood referenced British heritage and classic style in her limited-edition collaboration that combined the tradition of the English eccentric with a genderless approach to use of the check. The collection of classic check, double-breasted jackets, trousers, mini kilts, waist-length wrapped jackets, berets and an array of shoes and accessories showcased her irreverent and youthful approach to British heritage.

Burberry continues to protect its check from counterfeiters to preserve the integrity of the brand. Over the years, it has fought legal battles to protect its Haymarket check, most notably with Chinese bag maker Polo Santa Roberta. It has also been criticized, though, for its controversial actions to

OPPOSITE Rita Ora dressed from top to toe in check items from the S/S 2018 collaboration between Gosha Rubchinskiy and Burberry, which referenced the brand's chav past in a tongue-in-cheek blend of sportswear and crisp tailoring.

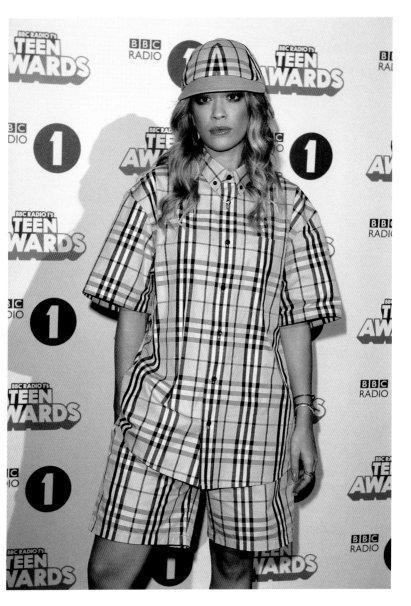

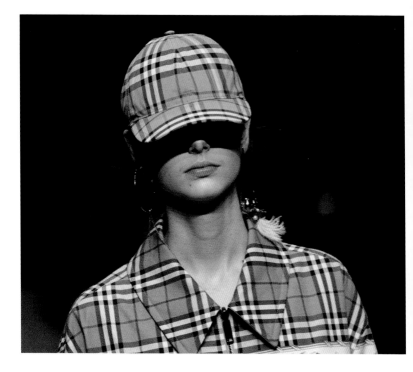

guard against counterfeiting and retain prestige, including destroying more than £28 million worth of unsold stock in just one year.

Today, the Burberry check is perfectly aligned with the values of a brand that stands for inclusion, optimism and the support of marginalized and underrepresented communities. This is best seen through its most recent iteration, the Rainbow check. Speaking to a socially aware generation, it continues to have global significance. Liane Wiggins, head of womenswear at MATCHESFASHION, explains: "Burberry has a very strong heritage and the label's vintage house check continues to be recognized worldwide as an iconic and desirable print."

ABOVE The newest edition to Burberry's repertoire, the Rainbow check, signals the brand's commitment to LGBTQ+ rights and social justice.

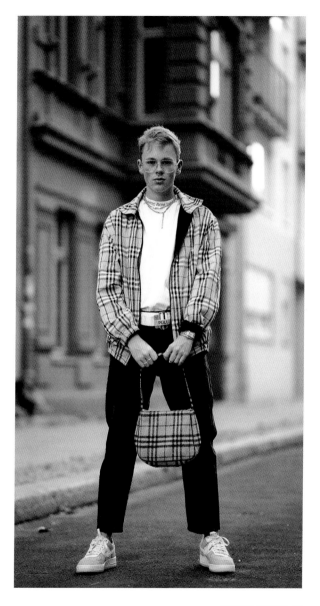

OPPOSITE Erik Scholz, the founder of @signsoflifeofficial, wearing Burberry check in Berlin, Germany in 2019, emphasizing its renewed appeal.

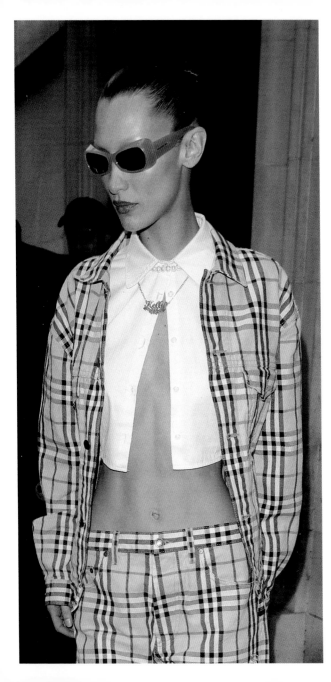

LEFT Burberry muse Bella Hadid steps off the catwalk of the A/W 2022 show. The Californian model wore an updated Nova check cropped jacket and low-cut shorts.

RIGHT The Burberry check shows little sign of losing its cachet. The brand's A/W 2022 Womenswear collection provided dramatic Instagrammable moments by mixing traditional Haymarket check with more contemporary upscaled streetwear-inspired patterns.

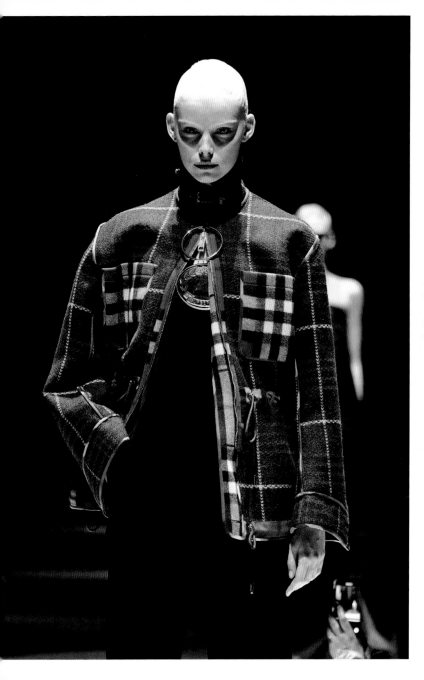

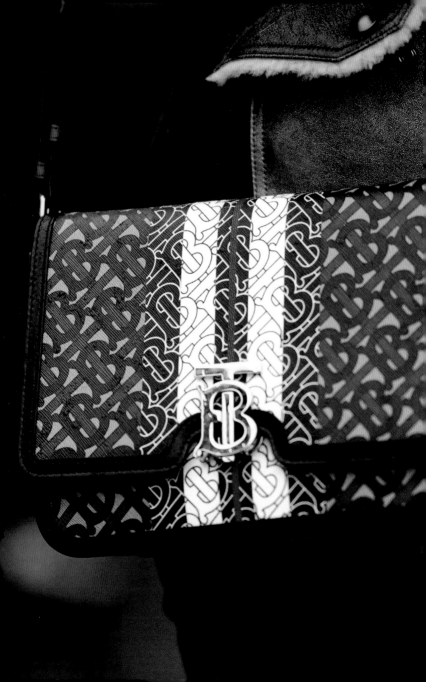

# EVOLUTION AND REVOLUTION

Many of today's great luxury fashion brands can trace their origins back to the early or mid nineteenth century, including Burberry, Hermès (in 1837), Loewe (in 1846) and Louis Vuitton (in 1854).

Typically, they did not become fashion brands until well into the twentieth century and so their goods did not carry logos or become heavily branded until then. The first recognized fashion house to carry a logo was the English fashion designer Charles Frederick Worth, who founded his fashion house in 1858. Worth applied his name to the lapel of a jacket and initiated a trend to use logos and monograms on the outside of clothing that would become an essential way to reassure customers of the authenticity, quality and originality of the clothes that they bought.

Throughout the nineteenth century, the advent of mass-produced goods meant more choices for consumers. This created a need to make products stand out. Manufacturers began creating trademarks, which drew from name logos

OPPOSITE Burberry quickly recognized the importance of its logo and has consistently mixed a strong graphic identity with traditional making techniques to apply logos to its covetable items.

and monograms into something more representative of a company. Trademarks could include colours, patterns, words, phrases, symbols, monograms and even shapes, some or all of which could be presented as a graphic design and legally registered as a representation of a company or product. The Trade Marks Registration Act passed in England in 1875, and saw trademarks then become valuable company assets. This was the first instance of branding as intellectual property, a form of intangible property resulting from creative endeavour. Legislation gave companies a way to protect themselves against imitations or counterfeit goods.

Thomas Burberry was quick to see the importance of creating a striking visual representation of his company to reflect its values, and launched a competition to design a logo for the company. The result was a detailed red and cream graphic that referenced heritage but also embodied vigour, determination and a desire to leap into the future. Originally designed in 1901, the Equestrian Knight logo for Burberry consisted of a knight, symbolizing honour, grandeur, pride and purity, on a charging horse conveying courage and freedom. The knight carried a shield, representing protection, emblazoned with the letter "B", and a lance with a banner bearing the inscription "Prorsum", the Latin word for "forwards". This communicated the company's ambitions and outlook, and was underlined by the wordmark "Burberrys".

Always an astute businessman, Thomas Burberry was keen to protect his business interests and products. He had the new logo registered as a trademark in 1904. The use of the logo on Burberry's core product, the trench coat, saw the logo become representative of the garment in the mind of consumers. For the next 67 years, the emblematic logo remained unchanged.

The first rebranding came in 1968, the year of youth-driven

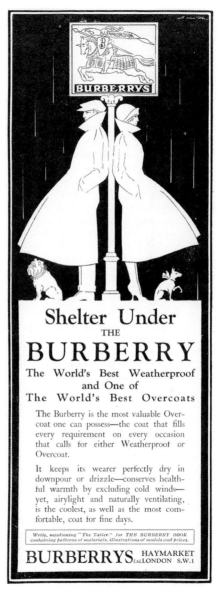

Shelter Under

THE

# BURBERRY

The World's Best Weatherproof
and One of
The World's Best Overcoats

The Burberry is the most valuable Over-
coat one can possess—the coat that fills
every requirement on every occasion
that calls for either Weatherproof or
Overcoat.

It keeps its wearer perfectly dry in
downpour or drizzle—conserves health-
ful warmth by excluding cold winds—
yet, airylight and naturally ventilating,
is the coolest, as well as the most com-
fortable, coat for fine days.

*Write, mentioning "The Tatler," for THE BURBERRY BOOK
containing patterns of materials, illustrations of models and prices.*

BURBERRYS *Ltd.* LONDON  HAYMARKET
S.W.1

protests and cultural rebellion, and emphasized modernity to breed a simpler, more stylized aesthetic. Many of the elements of the early logo disappeared and the emblem was abstracted to become a solid black silhouette, devoid of lettering or details. The "Burberrys" inscription, now set in sentence-case text, included "of London" below it. referencing Burberry's history and heritage but also the zeitgeist of the Swinging Sixties.

This iteration of the logo remained in use until 1999, when Burberry began to reinvent itself as a luxury fashion brand and wanted a logo that broke away from the utilitarian nature of its trench coats. A new logo was commissioned to reflect its confident, fresh aesthetic and strategic direction into the luxury sector. The Equestrian Knight logo became more prominent and the detailed white highlights returned. The logo became interchangeable with the Burberry check design, and both were used extensively on clothing and accessories. The word mark returned to uppercase lettering and "Burberrys of London" became "Burberry London".

By 2018, Burberry's visual identity had been portrayed by the Equestrian Knight logo with no substantive changes for more than a hundred years. Then a newly appointed creative director arrived: Riccardo Tisci.

Tisci was keen to make his mark, and a radical rebranding was about to take place. His vision for the brand was one of inclusivity, exuberance, diversity and originality. Working with graphic designer Peter Saville, he set about creating a fresh logo to capture the essence of this new creative vision. The cutting-edge logo would need to encapsulate the heritage and history of the company and Saville interpreted this brief to create an understated, refined, modernist style that did not feed superficial logomania.

Saville had been the creative vision behind the Manchester record label Factory Records and, through his award-winning work, had influenced a generation of young creatives. His fashion clients included Selfridges, Pringle of Scotland,

BELOW Burberry store awning referencing its first rebranding.

Jil Sander, John Galliano, Dior, Yohji Yamamoto, Stella McCartney and Calvin Klein – where he had worked with Raf Simons to reinvigorate the brand's identity.

Saville was a long-time collaborator with fashion photographer Nick Knight, collaborating on the launch of the SHOWstudio website. With a deep knowledge of fashion communication, Saville was ideally placed to understand how to translate the Burberry logo to appeal to a contemporary audience without abandoning its heritage. Drawing inspiration from the Burberry archive, he revisited a monogram first developed in 1908. The "T" and "B" of the founder's initials were interlocked to create the monogram "TB", following in the footsteps of luxury brands such as Chanel, Fendi, Louis Vuitton and Tom Ford. Saville commented in an interview with *Dazed*: "The new logotype is a complete step change, an identity that taps into the heritage of the company in a way

BELOW The Burberry logo hanging outside the campany's flagship store in London.

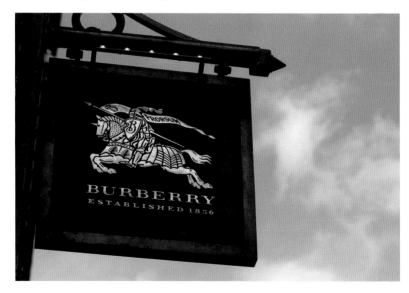

that suggests the twenty-first-century cultural coordinates of what Burberry could be."

The Equestrian Knight was removed from the emblem completely. For the first time, the word mark was used independently in a specially commissioned uppercase typeface. The words "London England" appeared underneath. Twelve versions were put forward for consideration.

Once selected, the new logo and monogram were unveiled, along with an even more daring initiative that placed the TB monogram into a repeating pattern. In a soft colour palette, the print was widely used in Tisci's first collection – on everything from bikinis, bucket hats and shorts to sunglasses and belt buckles in an exuberant, youthful collection steeped in elements of sportswear. But even when used in multiple pieces worn together, the modern aesthetic felt subtle and understated and did not revisit the era of "chav check". The collection also featured the brand's iconic check design and

ABOVE The 2019 "Burberry London" logo printed on caramel stationery and packaging, complete with gold ribbon ties.

effectively incorporated both the new print and check into individual garments.

To abandon the globally recognized Equestrian Knight logo was an audacious move, and it brought Burberry a fluid new identity that seamlessly moved across all product categories, "something to transcend the company provenance without denying it", according to Saville.

The first rebrand for almost 20 years was a success and contemporized the brand by creating a new shorthand symbol of Burberry. The company announced the new monogram via its Instagram page, establishing it as a progressive trend maker. The monogram print featured widely in promotions and was used to wrap landmark Burberry stores around the world – and even to cover a Hong Kong tram – in the beige, classic white, and orange honey print. Burberry also created inflatable bears 10 metres (32 feet) high and printed with the monogram to coincide with New York, London and Shanghai Fashion Weeks.

The monogram has also been integrated into natural landscapes across the globe, such as the sails of kite surfers in China and a display using drones to create the monogram in the sky above the Colorado desert – referencing the brand's historic connection with adventurers and outdoor sports.

The rebranding has opened up the label to tell a powerful story around its founder Thomas Burberry, who had hitherto remained hidden in its history unlike other founders of luxury brands.

Today, logos have a strong influence on the image of brands and leave a lasting impression that is greater than the individual identity of a designer. Of the brand's new print, Tisci said: "It's a symbol that not only embraces Burberry's heritage but also feels very contemporary. What I wanted to do with the collection was to celebrate the breadth of who we speak to as a brand."

BELOW A visitor wears a Burberry BT logo print scarf at Copenhagen Fashion Week in 2020.

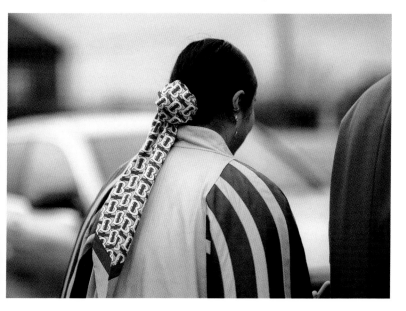

LEFT Hong Kong commuters ride on a double-decker bus decorated with the Burberry TB logo print in 2021.

# "IT" BAGS

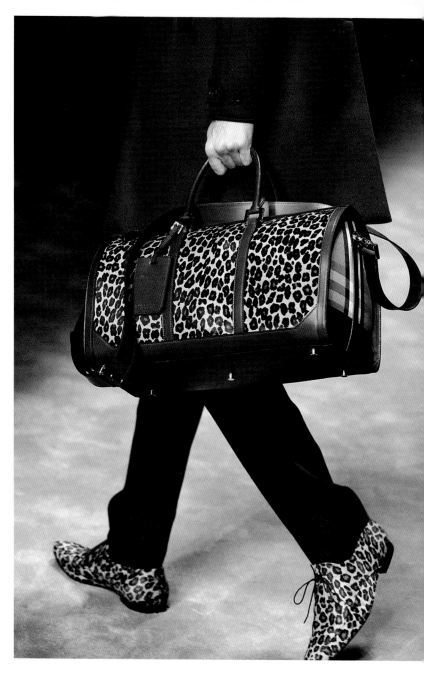

# ICONIC ACCESSORIES

The global success of Burberry is due to its continual evolution, from specialist outerwear manufacturer to fashion brand and now producer of leather goods.

Leather goods present an opportunity for growth and new lucrative product categories, such as bags, shoes and other small items.

In the late 1960s and 1970s, Burberry started to produce bags and accessories inspired by outdoor pursuits such as fishing, hunting and shooting. By combining functional elements – such as soft pouch pockets, flap fastenings and expanding bases – with classic styles – like crossbody bags, duffle bags, holdalls and weekender luggage – Burberry began to shape its leather goods offering. Bags were treated as an opportunity to feature the woven or printed Haymarket check, often trimmed with tan or dark brown leather. These added interest to Burberry's outwear ranges and capitalized on the excitement caused by using the check as a decorative element, fuelling consumer interest and sales.

OPPOSITE A bowling bag playfully reimagined in an ocelot print combined with Haymarket check, shown in the catwalk presentation of menswear for A/W 2013.

These successes were consolidated into more considered ranges throughout the 1980s, 1990s and early 2000s in the wake of the "It" bag phenomenon, which focused attention on designer offerings and created demand for iconic styles such as the Fendi Baguette, made famous as a result of being featured in *Sex and the City*, and the Balenciaga Motorcycle, carried by celebrities and supermodels.

By 2007, collections of refined bag shapes and fashion pieces were liberally sprinkled throughout the Burberry Prorsum collections for Spring/Summer and Autumn/Winter, taking edgy bags from the catwalk to the street. Understated, oversized slouchy totes and bucket bags for the spring, and quilted or studded metallic leather satchels and travel bags for the autumn spotlighted Burberry as a major player in the luxury leather goods market.

Today, leather goods are an essential part of Burberry's strategic growth and have helped the brand to capitalize on a global accessories market worth £434.9 billion in 2022. Nearly one third (30.9 per cent) of global sales were generated online. Burberry's initiative to build bespoke bags has also ignited interest in the brand, from new younger consumers as well as loyal customers.

The envelope-style Pocket bag, with its distinctive frame handles and oversized pocket detail, inspired Burberry to create a limited edition in 2020 in conjunction with the Chinese influencer and fashion blogger Tao Lang, otherwise known as Mr Bags. He has influenced many of his seven million followers to purchase luxury bags, and these bags were sold exclusively through him, guaranteeing that the limited edition of just 100 beige-and-red Pocket bags sold out on WeChat within a minute of launch.

Burberry's biggest shift in bag design came with the arrival of Riccardo Tisci, who transformed accessories. His creative and

OPPOSITE S/S 2010 London Fashion Week was the perfect showcase for Burberry's offering of oversized bags made from the house check and leather that would establish the brand as a producer of high-quality bags and accessories.

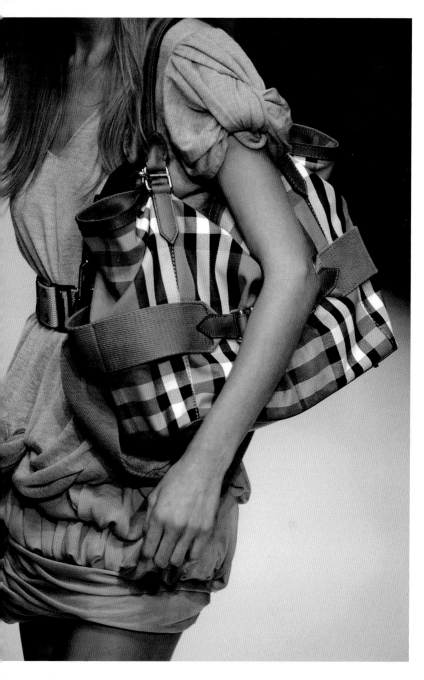

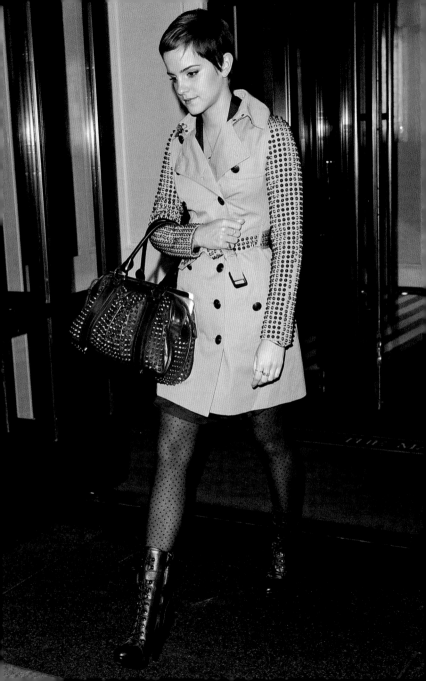

original designs cater to a wide range of consumer needs, for both formal items and sportswear-inspired accessories. His experience developing Givenchy's bag offering – alongside a perspective influenced by streetwear – saw him introduce a range of desirable signature shapes that have shifted Burberry from the periphery into the centre of the "It" bag space.

Products are manufactured in the Burberry leather goods centre in Italy, reflecting the brand's commitment to quality and exceptional craftsmanship. They combine woven and printed heritage checks, canvas and leather with an array of seasonal graphics, and the TB monogram.

## THE POCKET

Taking inspiration from the Burberry archive, Tisci uncovered the Michelle shopper, a long-forgotten soft luggage style sold in the 1980s. He reimagined the shopper into a range of soft and hard boxy totes, set inside a leather frame and featuring a wide pocket on the front. Such details gave the Pocket a distinctive urban feel while incorporating references to vintage gentlemen's luggage through contrast topstitching and generous leather bindings.

The Pocket comes in a range of sizes and materials, including a sustainable canvas produced using less water and $CO_2$ than traditional materials. This attention-grabbing style was used to introduce the brand's first bag campaign, featuring model Bella Hadid and inspired by the concept of the animal kingdom. Inez van Lamsweerde and Vinoodh Matadin, the Dutch artists and fashion photographer duo, were commissioned to push the boundaries of image-making to capture both femininity and animal instinct in the brand's campaign.

OPPOSITE A gamine Emma Watson steps out in New York wearing a studded caramel trench coat and carrying a studded black leather bag from Burberry's A/W 2010 collection.

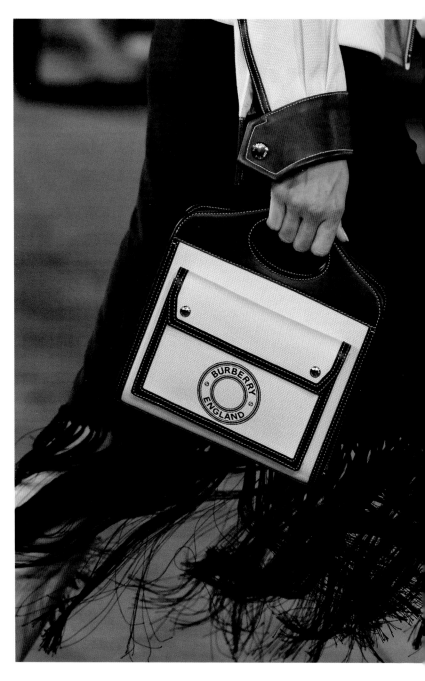

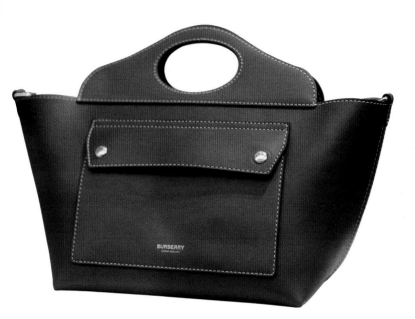

ABOVE The Pocket bag retains the sculpted handles, contrast top stitching and signature oversized pocket of the original, but has a soft body and scaled-down proportions.

OPPOSITE The archive-inspired Pocket bag. Made in canvas and leather, it was presented during the S/S 2020 fashion show.

## THE OLYMPIA

The Olympia bag first appeared on the catwalk in Burberry's Autumn/Winter 2020 show and found favour with an army of celebrities, affirming its status as an "It" bag. The Olympia combines practicality with originality and was inspired by Greek architecture – hence the name. It has added an extra flavour to Burberry's signature bag selection thanks to its sleek, curved structure. This perfectly formed, half-moon-shaped shoulder bag is achieved by using a wooden block for traditional hand moulding to mirror the contours of the body, and it fits effortlessly under the arm or in the hand. It references the Baguette bags of the 1990s, but this iteration has a contemporary silhouette and a polished leather surface. The Olympia comes in three proportions and multiple finishes, from classic black to camouflage print.

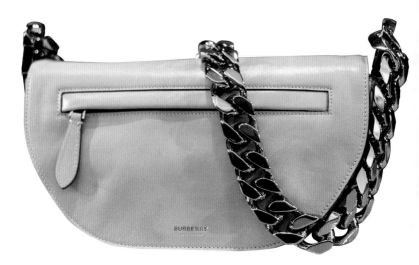

## THE LOLA

Named in honour of the song "Lola" by the Kinks, the 1960s British rock band, the Lola signifies confidence and self-expression. It pays homage to the legacy of Swinging London by encapsulating youthful rebellion and a devil-may-care attitude, but also references a more demure side of Englishness. It successfully straddles rebellion and refinement in a poised collection of structured shapes made from lambskin leather and given a softer silhouette through quilting or embossing in the pattern of the Burberry check. The bag is produced in a myriad of colours and has a chunky statement chain handle that can be slung over a shoulder or sedately handheld. Bucket, mini and satchel styles have been added to the original shoulder bag, all bearing the distinctive TB metal logo as a stylish piece of hardware on the front of the bag. The Lola was the focus of Burberry's 2022 bag campaign starring Bella Hadid, Lourdes Leon, Jourdan Dunn and Ella Richards, women who personify the character of the Lola bag.

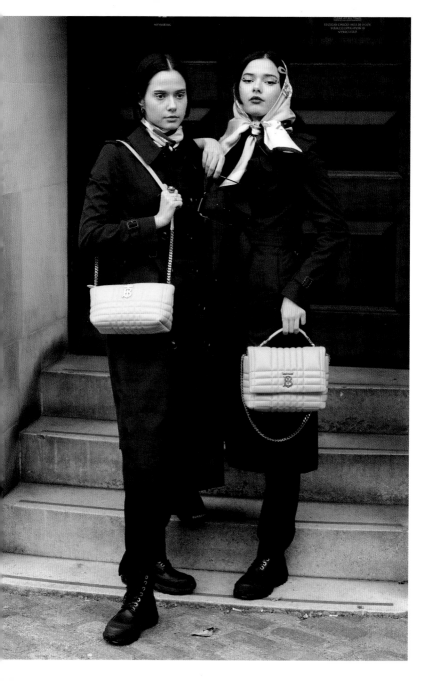

## THE TB

The TB bag is a signature piece from Riccardo Tisci's debut Autumn/Winter 2019 collection and presents as a more grown-up version of the Lola bag. With a structured, well-defined silhouette and signature TB monogram fastening, it retains a sense of unpredictability and individualism. The TB is a perfectly proportioned shoulder bag offered in three different dimensions to carry essentials or transition from day to evening. If you're looking for a luxury bag that will turn heads, the TB is the perfect choice. The body of the bag merges tradition and newness through exquisite craftsmanship and uncluttered design. It is made in fine calf leather or two-tone canvas, with adjustable chain or leather strap handles.

BELOW A TB bag, one of Burberry's new staples, in red leather with stand-out logo hardware.

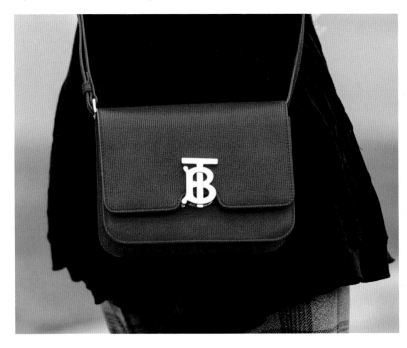

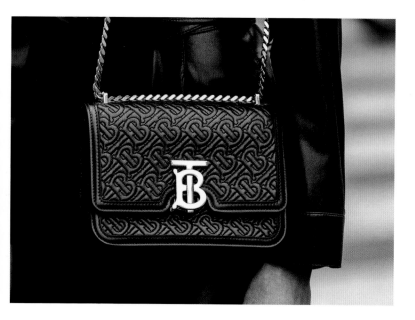

## THE TITLE

The Title bag gives the impression of formality with a utilitarian feel. Continuing the theme of reimagining archive pieces, it is based on elements taken from vintage military bags, reflected in its metal top bar and handles. It has roomy dimensions and a shoulder strap, echoing the practical bags of the 1940s. The Title bag comes in several sizes, functional enough for everyday use but also making a good evening bag. Its triple decorative metal-stud detail secures a front pocket, outlined in contrasting topstitched leather and sustainable canvas. The Title features a cut-out handle detail reminiscent of the lapels of a trench coat. Burberry introduced the Mini Title bag for its limited B Series Drop, but the bag proved so popular that versions boasting stripes, colour blocks, and animal and monogram prints were produced to meet demand.

# MEN'S BAGS

Through increased travel and the portability of technology such as smartphones, laptops, chargers and music speakers, men have adapted, as women have, to life on the move and now carry more items around. They have moved away from heavy formal leather briefcases and towards lighter, more practical alternatives and sporty styles that fit with active lifestyles. In 2017, one in seven (15 per cent) of British men bought a bag, according to market analyst Mitel. The trend has continued and the percentage increased, particularly in the luxury bag sector, where bags denote wealth and status.

Burberry's men's bags are artisan made, offering functionality amalgamated with trademark branding that is explored across core shapes such as totes, crossbody and bowling bags, backpacks, bumbags and messengers. The brand reinterprets classic styles through innovative combinations of specially commissioned materials such as nylon, sustainable canvas, fine leather and woven mesh.

Thomas Burberry's principles of durability and weatherproofing remain essential to the men's collections, with a distinctive streetwear flavour added to the mix through details such as quilting, decorative hardware, monochrome patterns, geometric prints, embroidery, embossing, drawstrings and carry straps.

Many of the new silhouettes from the women's collections also appear in the men's ranges, namely the Pocket, Olympia and TB bags, which have been rescaled into backpacks, crossbody bags, belt and bumbags, briefcase styles and a plethora of smaller leather pieces like wallets, luggage labels, and phone and card holders. This follows trends seen across other luxury brands: Dior's Saddle bag and Loewe's Puzzle bag have also evolved into menswear styles.

OPPOSITE To reflect shifts in social understanding of gender, Burberry has produced accessories such as the Olympia bag that occupy an ungendered space in the marketplace.

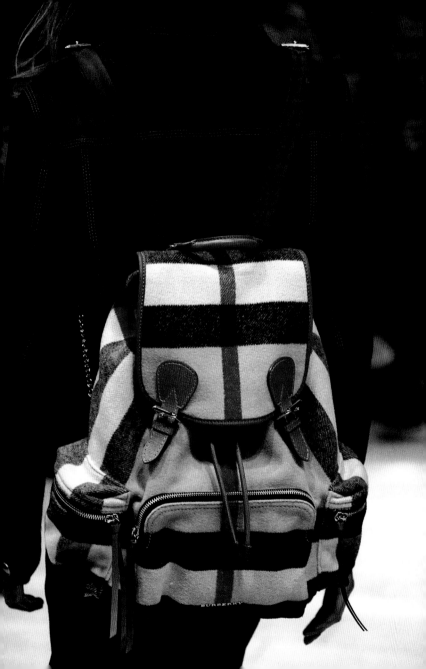

RIGHT A tiger print and leather messenger bag from the Burberry Prorsum menswear A/W 2013 show in Milan.

OPPOSITE A recurrent theme in Burberry's bags and accessories is the dramatic oversizing of prints combined with practical details such as carry straps, buckle fastenings and zip pulls, seen here in a backpack from the A/W 2016 collection.

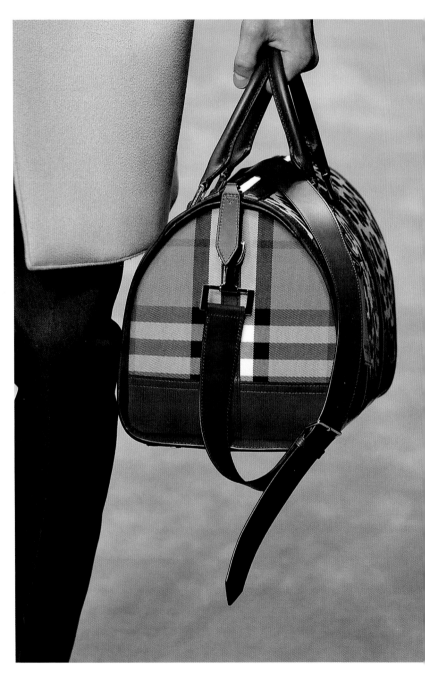

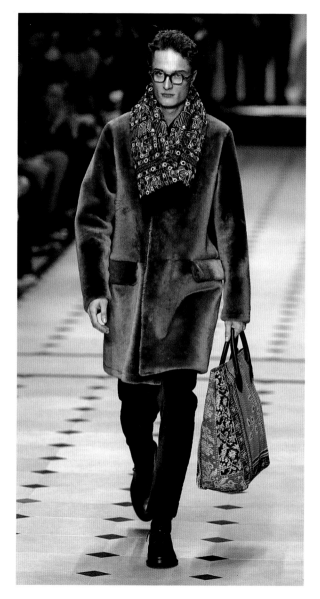

RIGHT Accessories styles are carefully integrated into collections to provide maximum impact on the catwalk: this simple shopper-style bag, combining opulent woven floral designs with navy leather trims, complements a petrol-green faux-fur coat and woven scarf from the A/W 2015 season.

OPPOSITE Burberry's success in building accessories collections lies in the brand's ability to reinvent classic styles using dynamic and eye-catching combinations of pattern and texture with heritage check.

# FOOTWEAR

Burberry has developed a large footwear offering, from festival-ready wellington boots, square-toed mules, patent leather sandals and pointed-toe, kitten-heeled court shoes to quintessentially British men's loafers, boots and classic lace-ups in polished leather or combinations of leather and classic check. Footwear is mostly manufactured in Scandicci, near Florence, Italy.

A growing category of footwear across all ranges are colourful branded trainers, reflecting trends towards more casual, relaxed styles of dress. Classic low-top styles – the Jack, Reeth and Salmond – feature the Burberry Haymarket check mixed with canvas and leather. Core trainer styles, such as the Arthur, Ramsey and Regis, sit alongside newer offers such as the Furley slider range and the Sub High-top textured, knitted nylon trainer which debuted for Spring/Summer 2022. The Sub references scuba diving footwear, with ankle straps and a thick rubber sole.

BELOW A closeup of the Burberry RS5 Low Top trainers, finished with the signature TB monogram.

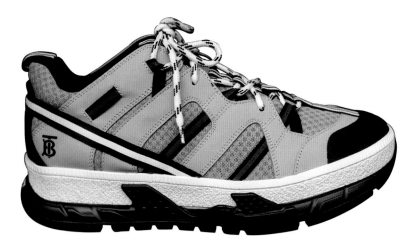

# OTHER ACCESSORIES

Burberry bags have spawned small leather goods, such as wallets, keychains and purses, all items usually carried in bags. They mirror bag-construction techniques, like embossing, quilting, binding, inlaying of fabrics, printing, punching, and contrasting stitching, and carry branded hardware to form part of a recognizable family of accessories. Bag styles such as the TB and Lola have matching wallets, card and phone cases, which can double as miniature bags (in line with recent trends).

There is also an expanding range of profitable handbag charms, including the Burberry Thomas Bear in leather and cashmere, monogrammed metal motifs, printed canvas motifs and even an iconic Haymarket check Air Pods case.

The menswear range includes classic belts crafted from leather or the Haymarket check and branded with polished TB monogram plaques.

Eyewear styles are highlighted with miniature logos and colourful lenses that vary in shade each season. Signature scarves, umbrellas, bucket hats, beanies and baseball caps all find a place within the Burberry accessories offering, forming a definitive handwriting. A range of gloves – in lambskin leather or panelled in check and lined in luxurious cashmere – are fastened with press studs engraved with the TB monogram motif or scaled-down TB monogram plates.

Burberry's jewellery collection adheres to an aesthetic spanning everything from chunky gold items to delicate diamanté face coverings. Its pieces are bold, made from precious materials and incorporate the TB monogram motif in a way that is overt yet sophisticated. The synergy between Burberry's jewellery and its bag hardware is obvious: the chunky monogramming, chains and studding create the perfect bag bling – and the witty, hip-hop-inspired jewellery in platinum

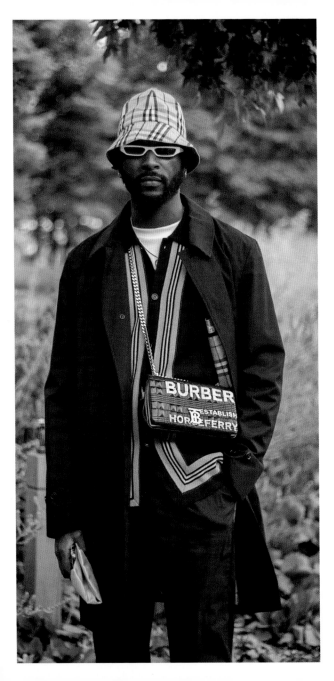

LEFT Bags such
as the Lola have
been rescaled and
added to Burberry's
menswear ranges
alongside hats,
gloves and eyewear.

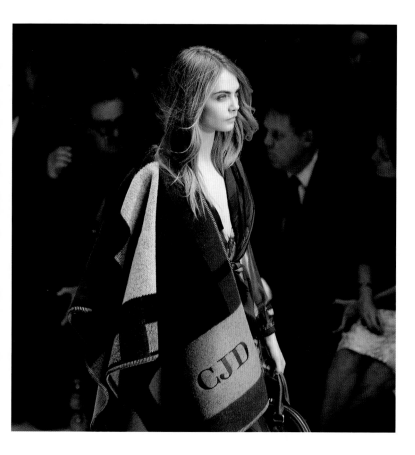

ABOVE At London
Fashion Week 2014,
the Burberry A/W
Womenswear show
featured models
including Jourdan
Dunn and Cara
Delevingne draped
in monogrammed
blanket scarves.

and gold is the perfect body bling for both men and women. Weighty cuff bracelets and rings incorporate the brand's logo lettering, earrings are sculpted to resemble chain links, while hair slides, cufflinks and tie clips all feature logos, setting up a recurring contrast between the brand's heritage and its future.

As part of a growing trend in the luxury sector, accessories are a way to form relationships with customers for whom these less expensive items offer an entrée into the world of Burberry.

# SHAPING
# THE
# FUTURE

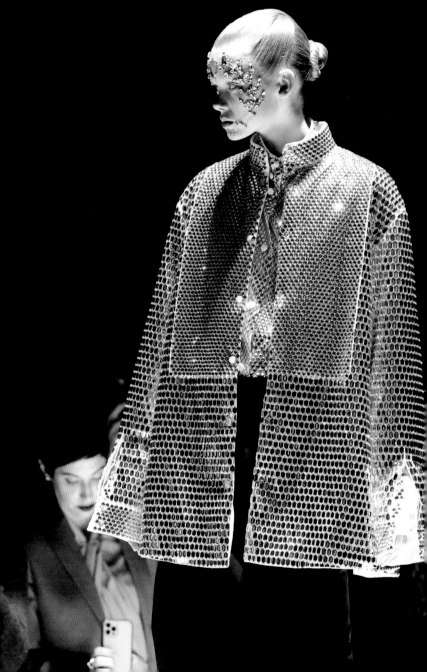

# SHAPING THE FUTURE

Despite its past successes, Burberry is a brand with its eye firmly on the future.

It has effectively adopted digital marketing to engage a new generation of consumers in a way that is convenient, innovative and user-friendly. Burberry's digital ambitions are reflected in its product designs, the creative contents of its campaigns, and its social media platforms and marketing channels.

It has elevated its brand identity into the digital space, establishing a definitive standard for brand storytelling. Digital innovation is a significant driver of growth, increasingly being the first step in a Burberry customer's purchasing journey.

It is no accident that Burberry occupies such a vast digital footprint. Rather, it is the result of the determination and vision of Angela Ahrendts. She was born in 1960 in Indiana, USA, to a businessman father and a homemaker mother. She achieved a degree in merchandising and marketing from Ball State University in Indiana and replaced Rose Marie Bravo as CEO of Burberry in 2006. Under her tenure, the brand value increased

OPPOSITE The A/W 2022 collection was instantly captured and shared by influencers and individuals posting on their social media accounts, increasing the reach and impact of the brand.

significantly, from £2 billion to over £7 billion. By 2012, she was the highest-paid CEO in the UK.

Ahrendts's objective was to make Burberry the first digital luxury brand and to sharpen and purify the brand message, in combination with excellent customer service. To achieve this, Burberry used platforms like Twitter, Facebook, Tumblr and Instagram for the majority of its campaigns. It has maintained a consistent signature across different platforms by cleverly using bespoke content for each channel. Facebook was used for live-streaming and exhibiting products, Twitter to increase engagement and interaction, and Instagram to share images.

In 2009, Burberry launched a website called Art of the Trench. This was the first major campaign in the digital space and featured everyday people wearing Burberry trench coats. Users could share photos, commenting and liking, and the site linked directly to Facebook. The first series of pictures was taken by Scott Schuman, the American photographer and creator of *The Sartorialist*, a fashion blog. The images tapped into a new audience and put consumers at the centre of the campaign, creating a connection with the brand.

Live-streaming of shows began with the Spring/Summer 2010 catwalk show. Within a year, Burberry had the largest following of any luxury brand at the time. Burberry also live-streamed its Autumn/Winter 2010 catwalk show in 3D to New York, Paris, Dubai, Tokyo and Los Angeles.

That same year also saw Burberry launch Acoustic, a campaign to celebrate emerging British musicians through collaborations and live performances. The artists wore Burberry products, aligning them with the company's identity as an authentic British brand. Songs were recorded exclusively for Burberry and shared via YouTube, garnering almost a million views. The campaign was supported by Sony and the British Fashion Council and ignited an international audience for local British talent.

OPPOSITE Through early adoption of technology and a savvy use of social media platforms, digital channels have become a core component of Burberry's business and a way to amplify its collections of modern understated elegance. The Burberry S/S 2017 show was the second see-now buy-now show livestreamed on YouTube.

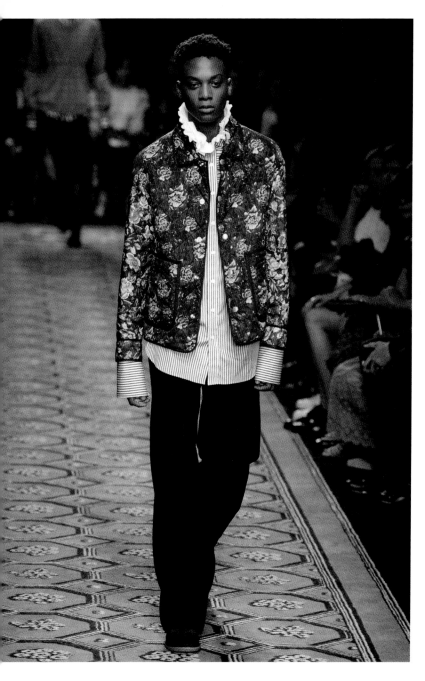

For the Spring/Summer 2012 collection, an event dubbed "Tweetwalk" gave customers a global exclusive: the show was live-streamed on the brand's Facebook page, and art director and photographer Mike Kus was commissioned to take pictures during the show and share backstage visuals. His followers could access these pictures immediately via Burberry's Instagram stream, increasing brand recognition and reach. Burberry's sales soared as select items – coats and handbags – were made available to purchase immediately. The campaign caused a sensation on Twitter in its attempt to democratize the catwalk and disrupt the power of fashion editors and buyers to select trends.

Burberry Kisses debuted in 2013, hosted on the dedicated platform KissesBurberry.com. People from 13,000 cities around the world participated during the first 10 days of the campaign, which allowed users to share kisses with loved ones around the world. This was a collaboration with Google to market Burberry's lipsticks as part of Google's Art, Copy & Code initiative to embed emotion within digital experiences. The website allowed users to send virtual kisses in the colour of their favourite Burberry lipsticks by using a webcam or by kissing a touchscreen device, and it recorded 253,000 search results during the campaign.

A personalized message could then be added, and Google Street View enabled users to track the journey of their kisses to the recipients. This was another digital first for Burberry: taking an experience in the real world and translating it into the digital space.

The Burberry flagship store in London's Regent Street is as digitally advanced as the online offering. The store has 100 screens and 500 speakers spread across the building, showcasing digitized Burberry content. Radio Frequency Identification (RFID) chips have been fitted in certain products, which can display video content on screens or in the changing rooms.

Burberry has approached its online shopping with the same commitment to excellence as the experience of shopping in its physical stores. Burberry.com is luxurious and customer-centred. The brand's engagement-building tools, including virtual events and exclusive digital content, create a bespoke experience. Advice can be accessed via a chat function to share photographs of a specific product or create styling options from different pieces of clothing. Shoppers can also schedule video calls with sales assistants, who will take them through collections or select items tailored to their needs.

Burberry was one of the first brands to see the value of smartphones to maximize personalization by creating interactive content that would capture purchases that could be made from a mobile phone. Easy-to-use apps enable customers to browse the latest items across collections, and augmented reality (AR) tools let them view Burberry products in their own environments. Further, the apps support storytelling around Burberry's values and its many community initiatives. Recent examples include a showcase of murals created by up-and-coming British

artists as part of the Burberry Supports Youth initiative, and *New Awakening*, a six-minute film by director Derek Tsang celebrating the arrival of a new spring.

Angela Ahrendts left Burberry in 2014 to become the senior vice president of retail and online stores at Apple. Burberry's historic transformation under her guidance continued despite her departure, and today Burberry is one of the most digitally innovative fashion brands in the world. Its Spring/Summer 2021 collection, In Bloom, was simultaneously presented virtually and in real life. A collaboration with Anne Imhof, the internationally acclaimed artist, and Eliza Douglas, the musician who created its original soundtrack, In Bloom was set in a forest and explored the boundaries between art, fashion and performance. A pre-show helped to attract 20 million comments by the day of the event, which was live-streamed on Twitch to 28 million viewers.

## THE METAVERSE

Burberry, like other luxury brands, including Balenciaga, has recognized the potential of augmented reality (AR) and virtual reality (VR). It has taken a lead in the metaverse, a platform

where gaming and fashion intersect. It is moving quickly to capitalize on this new marketing opportunity and continues to evolve digitally as customers become more connected and conscious of the metaverse as a new way to exist and be seen. In 2021, Burberry became the first luxury brand to partner with next-generation games company Mythical Games, creating one of the most effective fashion collaborations in the metaverse. The collaboration launched Burberry's first non-fungible token (NFT) collection within Blankos Block Party, an open-world, multiplayer metaverse game. The game featured limited-edition vinyl toys, branded with the TB monogram, living on a blockchain. The NFT collection included the Burberry Blanko, Sharky B, an NFT that could be purchased, upgraded and sold. In-game accessories, such as a jetpack, armbands and pool shoes, could also be purchased. The Burberry Blanko was so popular that it sold out in less than 30 seconds, and its jetpack sold out in under two minutes.

Burberry has used social media and digital platforms effectively to showcase its mission and values as a brand in relation to social purpose, and to set ambitious aims for itself as an organization, as captured in the words of Marco Gobbetti, Burberry CEO between 2017 and 2021:

> Burberry was built upon a desire to explore nature and the great outdoors, and they have remained our inspiration for more than 150 years. Drawing on this heritage, we are setting a bold new ambition: to become climate positive by 2040. As a company, we are united by our passion for being a force for good in the world. By strengthening our commitment to sustainability, we are going further in helping protect our planet for generations to come.

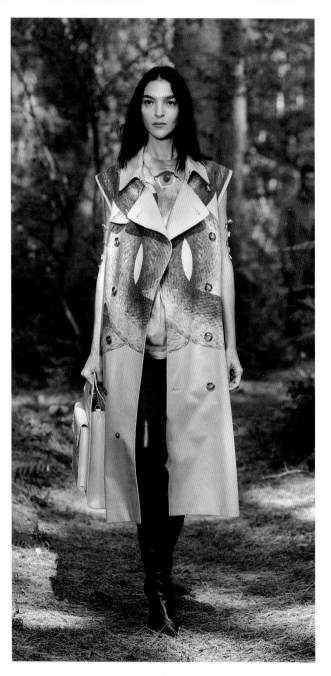

LEFT, OPPOSITE AND OVERLEAF No stranger to breaking the conventions of the catwalk, Burberry live-streamed the In Bloom show for S/S 2021. The audience-free presentation was part fashion show, part performance in collaboration with artist Anne Imhof, and made for compelling viewing. It starred an array of global celebrity models, including Erykah Badu, Rosalia, Steve Lacy and Mariacarla Boscono.

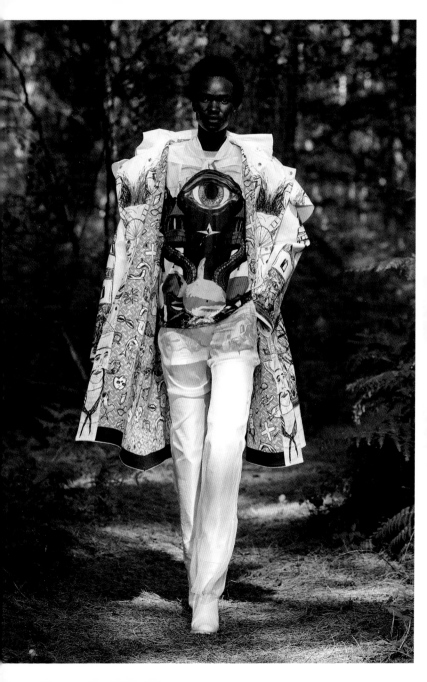

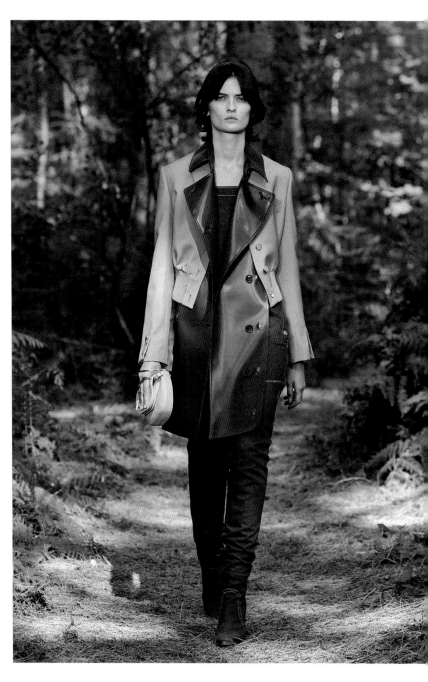

The brand's mission statement, "Creativity Opens Spaces", supports the choices it makes as an organization and demonstrates Burberry's commitment to creativity as a force for positive change. The statement also allows the boundaries for the brand, its audiences, and communities to be tested and redrawn, making environmental and social responsibility an essential component of Burberry's strategic mission.

Through the work of the Burberry Foundation and the Burberry Regeneration Fund, which was created in 2020, the company supports projects that help compensate and store carbon, promote biodiversity, restore ecosystems and support the livelihoods of local communities.

Taking a leading role within the fashion industry, Burberry has increased awareness of, and set standards on, issues such as the climate emergency, sustainability and regenerative design. It has reduced its market-based emissions by 92 per cent since 2016 and all of Burberry's events, catwalk shows and presentations have been certified carbon-neutral since 2019.

In 2020, Burberry became the first luxury brand to secure support from investors to finance the issue of sustainable bonds, where the proceeds exclusively fund green and social projects. Burberry already sources 93 per cent of its electricity from renewable sources. Other climate initiatives, such as reducing emissions and improving energy efficiency, means the company is on course to become carbon-neutral by 2022.

As a signatory of the UN Fashion Industry Charter for Climate Action, Burberry has taken a central role in developing online climate-action training for the fashion industry supply chain. It also supports the Fashion Avengers, a collection of industry leaders who inspire and accelerate progress towards the UN Sustainable Development Goals by raising awareness of fashion's impact on the planet. The Avengers also highlight ways to make changes in the way we produce, consume and dispose of fashion items.

# THE TRENCH
# TODAY

BURBERRY

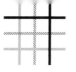

# TIMELESS AND TIMELY

The core driver of the brand, the Burberry trench coat, is a beautifully tailored piece of clothing that combines both masculinity and femininity through its contouring, detailing and colour palette.

A timeless and iconic piece of clothing, it is an exceptionally crafted item that takes highly skilled craftsmen up to three weeks to make. A perfect investment, the trench coat fits effortlessly into any wardrobe, looking elegant and easy teamed with jeans and a T-shirt or as the perfect addition to a printed day dress or tailored suit. A classic trench coat includes a collar fastening, wide lapels, button fastenings on the body that are usually double breasted, a cape or "storm flap" to allow rain to fall off, a waist belt fastening with a metal D-ring and adjustable cuffs that buckle around the wrists. It is made from waterproof materials in knee-length or full-length versions.

The classic trench is a recurrent hero piece in Burberry catwalk shows, its boundaries having been stretched to include looser silhouettes, less classic details such as zips and more innovative

OPPOSITE Cara Delevingne, Malaika Firth and Tarun Nijjer front the Burberry A/W 2014 trench coat campaign.

materials to form collections for men, women and children. In 2014, the brand launched the Heritage trench coat series, streamlined into three signature styles: the Chelsea, the Kensington and the Westminster. All styles came in two lengths, knee-and mid-calf length, and five colourways – classic caramel, black, dark military khaki, mid-grey and midnight, all lined with Burberry classic check. The Heritage range made finding the perfect trench an inevitability. There was a style, fit and colour for everyone.

The Chelsea is a slim cut inspired by the archive and contoured to the body. It has narrowed, rounded shoulders and a defined waist with a softly flared silhouette that works with items such as skinny jeans and other slim-cut clothing. The Kensington has a classic tailored fit, is made in Burberry's signature cotton gabardine and features all the traditional details of a trench, including epaulettes, hook-and-eye collar closure, storm flap, belted cuffs and D-ring belt. Its proportions have been updated to have a neat silhouette and squared shoulders that work over tailored pieces. The Westminster has a relaxed fit and an easy, fluid silhouette that lends itself to layering and more casual styles of dress. Its shortened sleeves make it ideal for lighter weather, and the coat is finished with a contrasting check lining and undercollar.

Recently, additional styles – namely the Waterloo and Pimlico trenches – have been added to the Heritage range in muted pinks, dark browns, caramel, khaki and grey, while contrasting textures and materials tell a more contemporary story. The Waterloo is made in both short and long lengths, cut in a more modern style but still retaining classic features, including D-ring belt details and double-breasted fastenings. The Pimlico is born out of Burberry's motoring heritage and takes style features from a classic car coat, including a set-in sleeve detail and a single-breasted fastening. It is softly tailored, with a straight-cut body that accommodates layers underneath.

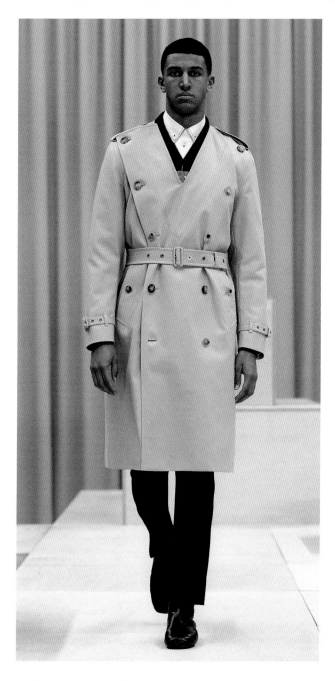

RIGHT A model wears a restyled classic trench coat during the A/W 2021 menswear show.

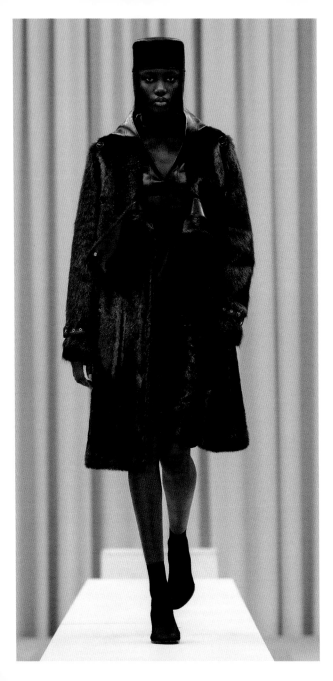

LEFT Designed
originally as a
functional item,
the trench coat has
found its place in the
fashion landscape
through its constant
evolutions – as
this faux-fur and
leather version
from the A/W 2021
womenswear show
demonstrates.

OPPOSITE Tiffany
Hsu wearing a
Burberry trench coat
with neon detailing
during London
Fashion Week in
2018.

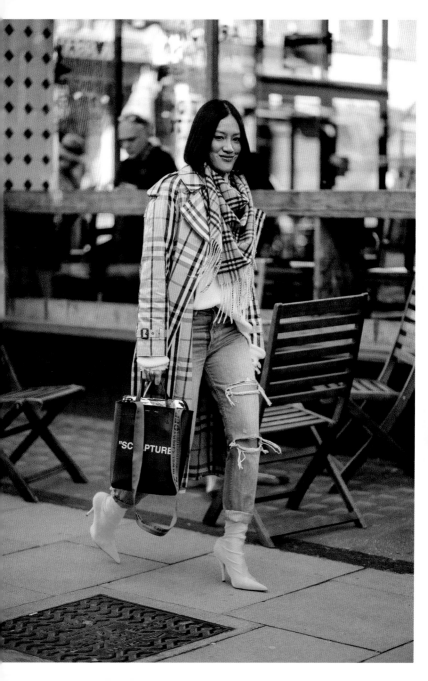

Since its inception, the Burberry trench has enjoyed the patronage of celebrities and people of note. It was famously worn by Sir Winston Churchill, Britain's wartime prime minister, and actors Marlene Dietrich, Michael Caine and Meryl Streep. In the 1980s, Michael Douglas, as Gordon Gekko in *Wall Street*, and Lauren Hutton, in the film *American Gigolo*, both wore Burberry trench coats. As the brand's fortunes increased in the 2000s, the trench coat enjoyed a surge of interest from royalty, actors, models, sports personalities and music icons alike.

Catherine, Princess of Wales, donned a chic variation on the classic Burberry trench coat with a soft flared skirt on a visit to Belfast, Northern Ireland, in 2011, ensuring the style sold out in days. Traditional men's styles have been popularized by music mogul and fashion guru will.i.am, who has embraced both classic and contemporary iterations. In 2012, will.i.am and athlete Denise Lewis arrived at the Burberry catwalk show during London Fashion Week in the same short, caramel-coloured trench coat trimmed in leather. British actor Tom Hardy chose to wear a classic Burberry biscuit-coloured trench for the red carpet European premiere of his film *The Dark Knight Rises* in 2012.

Hollywood A-listers such as Katie Holmes and Charlize Theron, and influencers such as Kim Kardashian have also been seen wearing this style staple as a mark of elegance and glamour. Victoria Beckham, the singer turned fashion designer, has an extensive collection of Burberry trenches and obviously has an eye for quality and design. She has been pictured wearing trench coats in rust and teal leather, along with more demure caramel mini versions and longer trenches in navy and black.

Emma Watson, best known for playing Hermione Granger in the *Harry Potter* films, has featured in several Burberry ad campaigns, as have the models Naomi Campbell, Kate Moss and Cara Delevingne — and all have made the trench the item

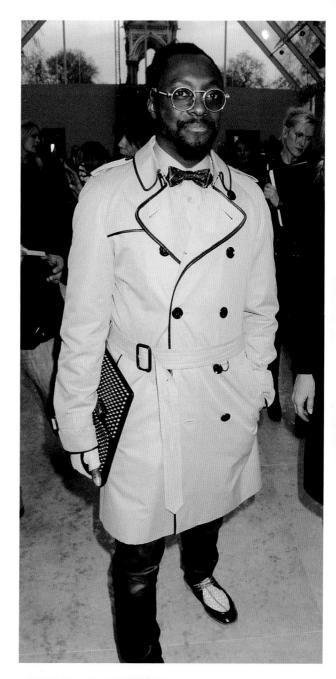

RIGHT Fashion show veteran, will.i.am who is known for his avant-garde style, chose to wear an minimalist trench featuring a black leather trim at the star-studded Burberry A/W 2012 womenswear show.

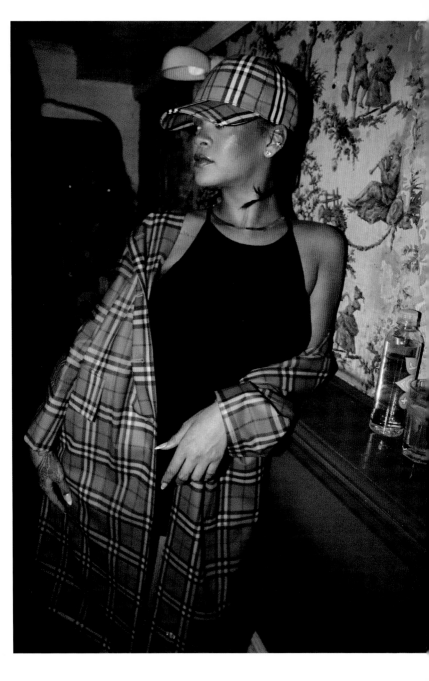

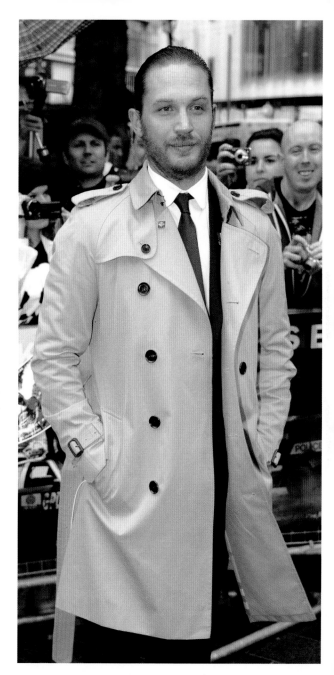

RIGHT Actor Tom Hardy wearing a classic caramel Burberry trench coat for his appearance at the UK premiere of *Edge of Tomorrow* in London in 2014.

OPPOSITE Rihanna attends SZA in concert at The Box in New York City in 2017, showing how to wear top-to-toe nostalgic Burberry check, and making a statement in a printed baseball cap and trench coat.

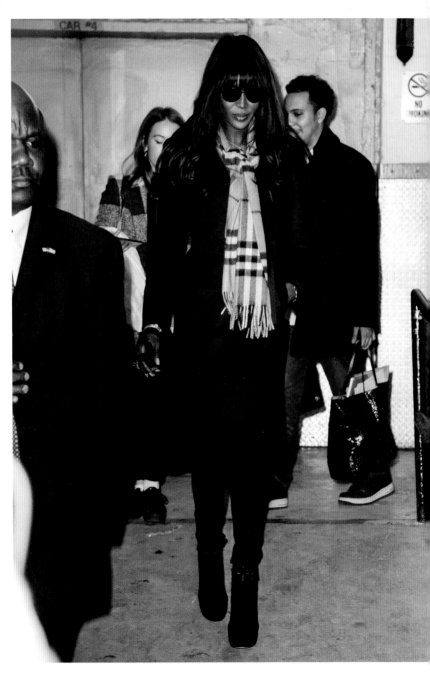

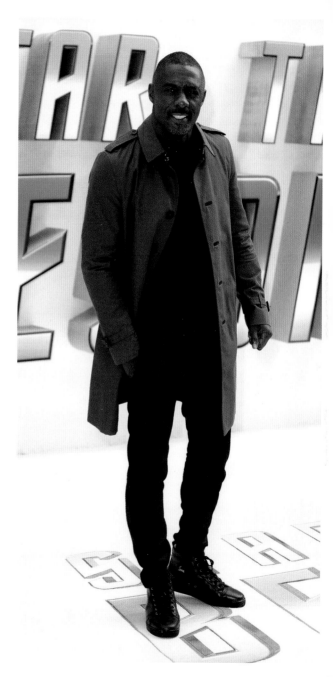

RIGHT Idris Elba's eye for fashion saw him attend a red carpet premiere in 2016 wearing an ultra-modern, single-breasted, straight-cut style.

OPPOSITE One of Burberry's original models, Naomi Campbell, leaves the Huffington Post Studios in New York in 2015 wearing a classic, double-breasted Burberry trench coat matched with a Haymarket check scarf.

of choice in their everyday wardrobes, away from the catwalk or the screen.

Sportier styles of trench have been popularized by Harry Styles, the singer, songwriter and actor who was crowned the top style icon worldwide in 2021, and actor Idris Elba, both connecting to a youthful and less conservative audience. In 2016, Elba wore a dark beige, single-breasted, straight-cut trench coat with multicoloured buttons to the premiere of *Star Trek Beyond*. Singer and actor Rihanna is known for her fashion influence thanks to her constantly evolving image and her own highly successful fashion line, Fenty. She was awarded the Fashion Icon Award by the Council of Fashion Designers of America in 2014 and chose a gold silk classic-cut Burberry trench to wear to her Fenty Beauty talk in collaboration with Sephora in 2019.

Gen Z songwriter Billie Eilish loves oversized silhouettes and selected a scaled-up Burberry trench coat to make a statement on the red carpet at the BRIT Awards in 2020, held at the O2 Arena in London. The following year, Selena Gomez, the influential producer, actor and singer, was snapped sporting a Burberry gabardine trench coat complete with zip detailing as she left the Ed Sullivan Theater in New York after her appearance on the *Late Show with David Letterman*.

The last word in trench coats has to go to an icon of popular culture: the singer, actor and queen of reinvention, Madonna. Madonna has been a permanent fixture at Burberry shows for more than two decades and has worn the coat in all its forms. She has managed to breathe new life into every iteration of the trench to exude a blend of sex, androgyny, elegance and informality. This most desirable of Burberry items has evolved over more than150 years, from functional item to fashion favourite, without losing any of its cachet. Today, it shows no signs of slowing down.

OPPOSITE Award-winning icon and queen of reinvention Madonna wears a classic trench coat at the MTV Video Music Awards show in 2021 in New York, accessorized with a military cap and corset.

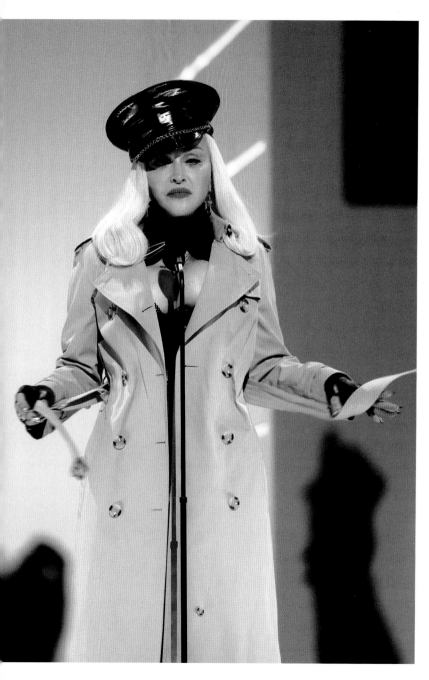

# INDEX

# CREDITS

The publishers would like to thank the following sources for their kind permission to reproduce the pictures in this book.

**Image Courtesy of The Advertising Archives:** 32, 33, 45, 50, 63, 76

**Alamy:** Art Directors & TRIP 81, 94; colaimages 34; Collection Christophel 35; Matt Crossick 84; Grzegorz Czapski 47, 58, 142; f8 archive 23; Granger - Historical Picture Archive 28; PA Images 83

**Bridgeman Images:** Look and Learn 22;

**Camera Press:** Thomas Lavella/Figarophoto 75

**Getty Images:** Tolga Akmen 13, 128; Richard Baker 97; Vanni Bassetti 66; Dave M. Benett 149; Edward Berthelot 90, 114, 116; Victor Blackman 36-37; Bloomberg 96; Gareth Cattermole 16, 72; Central Press 78-79; Evening Standard 39; Express 31; Fox Photos 30; Ian Gavan 8, 107; Handout 62, 136, 137, 138, 145, 146; Hulton Deutsch 20, 40; Samir Hussein 60; Melodie Jeng 61; Keystone-France 38; Eamonn M. McCormack 65; Arnaldo Magnani 108; Mike Marsland 51,153; Neil Mockford/Ricky Vigil M 86,

113; Jeremy Moeller 85, 99; Johnny Nunez 150; John Phillips/BFC 6, 9, 17; Print Collector 25; Ben A. Pruchnie 15; Jun Sato 55, 57; Lawrence Schwartzwald 95; SOPA Images 100-101; Jeff Spicer 131; Ray Tamarra 152; Karwai Tang 87; Christian Vierig 115, 147; Victor Virgile 67, 68, 69, 104, 110, 118, 120, 121; Theo Wargo 155; Stuart C. Wilson 134; Vittorio Zunino Celotto 119

**Mary Evans:** Illustrated London News Ltd 93; Retrograph Collection 24

**Shutterstock:** 53, 151; William Barton 133; Corri Carrado 54; Grzegorz Czapski 12; James Gourley 80; Keith Homan 11; Joew21 111, 112; NarCoss 4-5, 18-19, 42-43, 70-71, 88-89, 102-103, 126-127, 140-141; NeydtStock 122; Pixelformula/Sipa 49; Ugis Riba 98; Elena Rostunova 10; Snap 41

**Topfoto:** 27

Every effort has been made to acknowledge correctly and contact the source and/or copyright holder of each picture and Welbeck Publishing apologizes for any unintentional errors or omissions, which will be corrected in future editions of this book.